SO YOU THOUGHT YOU COULDN'T DRAW™

By SANDRA McFALL ANGELO

DISCOVER ART PUBLICATIONS / SAN DIEGO/ CA

So You Thought You Couldn't Draw™

Published by: Discover Art, P.O. Box 262424, San Diego, CA 92196
Call Toll Free: 1 (888) 327-9278. Third edition.

Copyright ©1989, 1994, 1995, 1998 by Sandra Angelo
First printing 1994
Second edition 1995, revised.
Third edition 1998, revised.

1. Drawing 2. Art

Library of Congress Catalog Card No. 95-078792

ISBN 1-887823-24-7 $22.95 Softcover
UPC Code 03247

Printed in U.S. A. CIP 95-078792

Layout & Design by Ken Cook

Illustrated by:

**Sandra Angelo, Tiko Youngdale,
and Gré Hann.**

Contributing students:

**Orville Thompson, Marilee Johnson, Peggy Palmer,
Grace Igasaki, Nancy Kearin, Leslie Owens, Joan
Endres, Bob Baker, Bob Estelle, Joe Breault,
Gordon Kleim, Doris Mountjoy, Don Yinger,
Rose Marie Barr and Maggie McHale.**

Design and Layout by:

Ken Cook

This book is dedicated to the memory of Virginia and Ernest McFall, whose amazing lives taught me by example that there wasn't anything I couldn't do if I had faith.

How To Use This Book

Begin at the beginning and work your way through the book sequentially. Read and follow all the instructions carefully. This is especially key for rank beginners. These methods have been tried and proven on thousands of students so you would do well to follow this sequence carefully. If you skip portions and jump all around, you may not improve as dramatically as the artists you see in the beginning of this book.

When you get to Chapter Seven, it is permissible to work out of sequence. Those drawings are presented in a loosely structured format, with the easiest subject first, gradually progressing toward the most difficult. While, it's always good idea to begin with easy objects and move toward the most challenging, by the time you reach this chapter, your skills may be strong enough that it wouldn't hurt to jump around a little. Generally, if you look at a drawing and think it's easy, it probably will be, especially if it's a subject you like.

Many folks are reading learners who can learn to draw by simply reading the book and practicing the exercises. Others are visual learners who need to watch the instructor's hand and see exactly how to shade. If you are having a problem with your shading techniques, you may want to purchase the three companion videos that demonstrate this book's lessons. *Drawing Basics* will walk you through the first half of the book and show you how to shade and more. *The Easy Way to Draw Landscapes, Flowers and Water* and *The Easy Way To Draw Animals* will demonstrate various drawings in this book. (See order form in back.)

If you choose to use the videos, be sure to play them over and over again until you fully grasp the shading techniques. Some students have found they have to repeat the lesson several times, drawing along with the instructor, watching the demonstrations again and again before it finally sinks in.

Many folks ask me, 'How long will it take me to learn to draw?' My answer is, 'How many hours per day are you planning to practice?' There is no magic number of days for this process but as a general rule, students who draw for 45 minutes to one hour per day, usually finish the book in 60-90 days.

If you are looking for structure, set a goal of learning to draw in 90 days. Read chapters one through three in the first day or two. Then practice the exercises for about 45 minutes to an hour daily. Mark off your calendar with the number of drawings you have completed that day. For those of you who are on a busy schedule, you can always find at least 45 minutes each day to relax. If you have more than 45 minutes to devote to drawing, that's great. As you begin to improve, drawing will become a retreat where you can enjoy quiet serenity. You won't believe how much fun it is to draw. So turn the pages and let's get started!

Contents

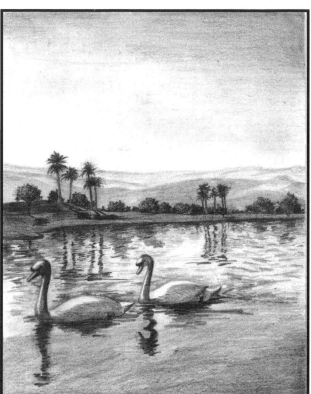

Introduction

|||

Transform your skills from amateur to artist in a few easy lessons ...

Didn't you just hate that kid who was over in the corner drawing super sonic jets when your airplane looked like a goose egg with webbed feet? Or that little girl with the blonde braids who drew horses from the Winner's Circle when your horse looked like a mutant rat on stilts?

Well, if your art never made it to the bulletin board at school and not even to your own mother's refrigerator, here's your chance to avenge yourself and clear your besmirched reputation. Forget losing 30 pounds, tummy tucks, hair implants, or face lifts. After completing the lessons in this book, you will be able to draw a perfect mask to wear to the upcoming high school reunion! You'll show them! No more irreverent snickers or giggles for you.

Now that I've promised you the ability to draw the perfect body, I really do need to insert a disclaimer. This foray into the world of art will not be unlike your first date. You will feel awkward at first, you will spill things, mess things up, you'll feel like a fool at times and wonder when it's going to be over. But like any good friendship, the more time you spend at it, the better it gets.

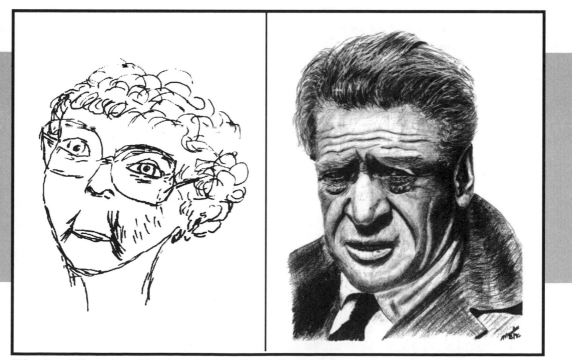

Fig. 1 — These two drawings by Marilee Johnson were seven weeks apart.

What makes you think I can do this?

You've always wanted to draw but you thought you had to be born with talent. I have fabulous news. It's not true! After working with thousands of people who can't draw a straight line, I have developed a sure fire four step method (described on page 43) that will take you from drawing like an amateur to drawing like an artist in a few easy lessons.

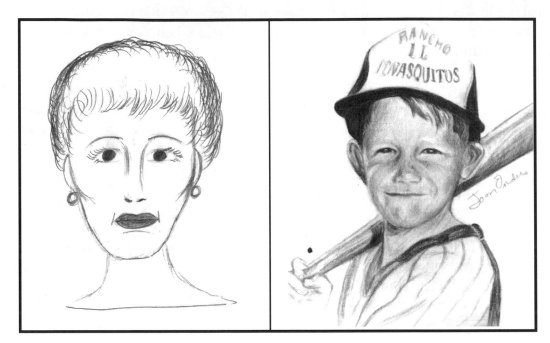

Figure 2 — In eight weeks Joan Storms went from drawing with weak skills to rendering this superb drawing of her little grandson.

One of the biggest frustrations for rank beginners like yourself, has been the lack of simple books; art books which assume you know NOTHING. Instead of starting you in first grade, many skip straight to the tough stuff. At last, there is a book written just for you! I'll tell you everything! Which side of the paper to use, which end of the pencil to sharpen, which eraser is best for which pencil, etc. I assume nothing. If you are already past this stage, simply exclaim, 'Pshaw, I know that!' and move on.

This is the first art book designed for people who have no natural talent. It contains lots of information and data that I have gathered from many years of research while teaching people who showed up for class with no more than a desire to get revenge on that Esmerelda Fishback who walked away with all those art awards. I listened to these rank beginners as they watched me draw, and when they said things like,' Look she's pressing harder

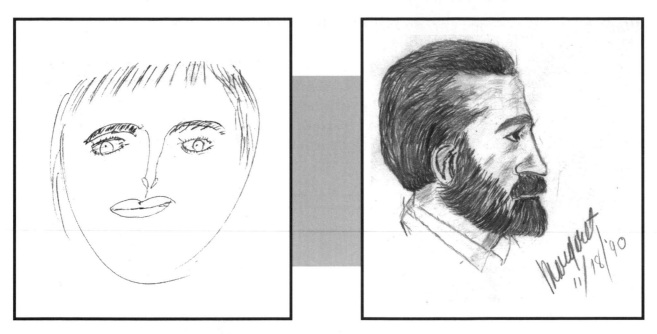

Fig. 3 — Maggie McHale dramatically improved her drawing skills in just a couple months.

and she just turned her paper around,' the next time I taught , I said, 'Now you press harder and turn your page a little.' (Pretty smart eh?) So now you're the lucky beneficiary of their experience. They taught me what you need to know in order to learn to draw.

Com'on, have you seen me draw...?

More good news! Talent is REALLY not necessary. There are only four ingredients required for drawing success.

First, you must have a burning desire to learn. Whenever one tackles a completely new skill, they often feel intimidated by unfamiliar new terms and the awkwardness of their first steps. A fervent desire to draw, patience, & a willingness to make mistakes will help get you through the times when your flowers turn out looking like mutant potatoes.

Second, you must have fine motor skills and adequate eyesight. Any adult who can write their name has this. (More good news! If you can't draw a straight line, that's great! Most of the lines in art aren't straight. We artists leave straight lines to machines and rulers.)

Third, you must practice. As with any endeavor, practice makes perfect. There is a time meter connected to your hand. The more you draw, the more time you accumulate on the meter. After a certain amount of practice time, you automatically learn to draw.

There is actually a direct cause and effect relationship between practice and successful drawing.

 And the last, and most important ingredient is persistence. The race goes not to the hare but the tortoise. Those who don't give up, succeed. You will be happy to know that in twenty years of teaching, I have never had a single student complete the course without learning to draw, no matter how weak their start. (Look at the before and after drawings in this book!)

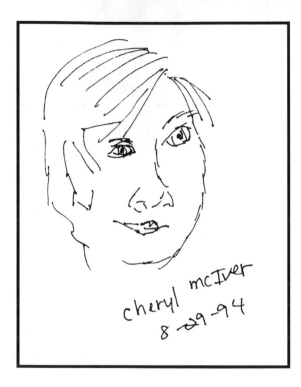 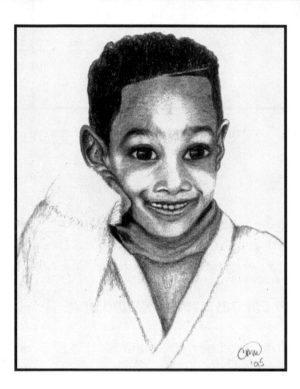

Fig. 4 — Look at the remarkable progress made by Cheryl McIver when she studied the masters' drawing techniques. These drawings were done five weeks apart.

Materials

|||

Pencils

All the exercises in this book are done with a graphite drawing pencil. These pencils are available in varying degrees of hardness. The density of the pencil will determine how dark or light the mark will be, how smoothly the lead will lay down and how long your pencil will stay sharp. In the beginning I recommend that you draw strictly with graphite. It's enough to learn all the drawing techniques without having to figure out how to use different products. Once you master graphite, you can begin to explore other drawing media. In my second book, I will include a section on exploring drawing media. Trying various new media is only fun after you know the basics of drawing.

The density chart below shows the varying degrees of hardness commonly available. Keep in mind that the performance of each pencil will vary greatly from brand to brand. The pencils I have recommended in my kit are specifically selected to give you the maximum range of performance. It really matters what brand you use. They are not all equal. All the enclosed exercises were done with my brand, so if you are not getting the same results I do, you may want to switch to my pencils.

Warning: If you use the wrong pencils, you can press down all day and your paper will get crushed but your values will never get darker. With a good quality pencil, you can get a very wide range of values. I have a philosophy that says, "Use junk, you get junk. Use good stuff, you blossom." Don't come whining to me if you use bad pencils.

Drafting Pencils								**Drawing Pencils**					
6 H	5H	4H	3H	2H	F	H	H B*	B	2B	3B	4B	5B	6B

← Harder & Lighter

Softer & Darker →

On this side, the higher the number, the harder the lead will be and the lighter the mark. i.e. 6H will make a lighter mark than a 2H. Because these pencils have a hard lead they will stay sharp longer and give you more detail.The pencils on this side are mainly used for drafting,engineering, architectural rendering, and other work where there is a need for a sharp lead and fine detail.Although some artists use them, most primarily use the pencils on the other side.

As the numbers get higher on this side, the leads get softer and darker. i.e. You will achieve much darker marks with a 6B than a B. These pencils are excellent for soft shading but will dull quickly. Most artists limit themselves mainly to the pencils on this side. On rare occasions where they need light values, like blonde hair, they may venture over to the other side and grab an F.

Figure 5

*The HB is the lead generally used in the common yellow household pencil with that terra cotta eraser. While you can take great phone messages with this, it's pretty lousy for creating deep dark values or soft gradations. If you are a 'hatcher', (meaning you don't mind if your lines show), you might like the HB . If you are a 'graduator', and like soft changes in value, (with no lines showing), you will probably prefer using the B leads.

Because it may drive you to the loony bin if you try to memorize the density charts on page 5, and remember when to use which pencil, I have devised a somewhat idiot proof system for drawing with graphite. I took the three most commonly used densities and labeled them, light, medium and dark. For example, when you want to deface your boss's portrait with blackened teeth, you would use the dark pencil. When you want to draw your Uncle Floyd's silver hair, you would use the light pencil.

Later, in the chapter on shading, you will learn how to create a full range of light and dark values by using only one pencil density. Although I personally don't switch pencils very often, when I want to enhance a dark area I use a 6B. If I want to get a delicate, light stroke I grab an F pencil from the left side of the chart.

I'm not sure how or why the F wandered onto the left side, but somehow it did. (Who knows, maybe Mr. Chartmaker was a bit inebriated that evening, or maybe his wife Myrtle changed it in the middle of the night to sabotage him for not picking up his underwear, or maybe his first name was Floyd and he wanted to name a density after himself, or maybe... woops, we're digressing.) Anyway, in my opinion, the 'F's' texture is more suited to the B side of the chart, but then I wasn't around when this chart was invented, so there was no one to set them straight.

> **TIP**
>
> Keep in mind, the best way to make lights look really light, is to place strong darks behind them. So, when you are drawing a blonde, you would often use the medium and dark pencil in the shadow areas so as to emphasize the strong light highlights. Even if you just paid $100 to get rid of those dark roots, you must place strong shadows at the roots so as to anchor the hair to the head. Remember, just because a subject is light, doesn't mean you only use light pencils. Even light subjects have medium and dark shadows.
>
> **One More Tip**: In my opinion, (which is ~~always~~ usually right), the H pencils don't mix with the B's very well. The texture of the pencil is just so different that I personally don't like the way they blend. So, when I want to achieve a really light value and can't get it with my B leads, I select the F pencil from the left side of the chart.

GETTING ACQUAINTED WITH YOUR PENCILS...

Whenever you try out a new tool, it is best to test it and see how it works. Most realists hold their pencil like they would hold a pen. When they draw, they use tight, controlled strokes, drawing with their fingers. This allows them more command over their marks. Artists who do impressionistic, (or abbreviated) renderings like to grasp their pencil like they would a brush. They use arm movements, holding their pencil at a distance, making loose, casual strokes. You might want to try both methods to see which feels most comfortable to you. You may even find that you like to mix it up, drawing the landscape loose, then detailing the goose bumps on a plucked chicken with tight, controlled strokes.

In this book, I have both realistic and impressionistic drawings. My drawings tend to be very exact and delicate. Don't be concerned if your style is not like mine. Look at Figures 8 - 10. We all drew the same subject, yet each person's style was unique and differ-

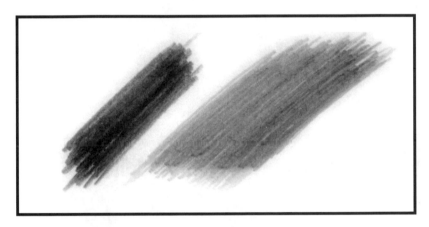

Figure 6: Here is a sample of the texture created by using an H pencil. On the left is a swatch drawn with a 2B. In my view, these two textures don't mix properly.

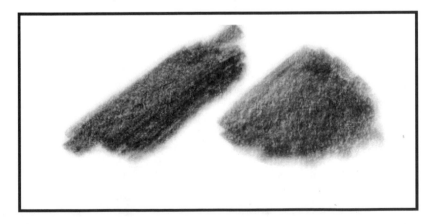

Figure 7: Here is a swatch drawn with an F pencil. I have blended it into a 2B. In my view, these two pencils' textures look more compatible.

ent. Each of you will have a slightly different style. Just as it is with handwriting, every-one is unique, so, don't be concerned if your drawings don't match the ones in this book exactly.

*Figures 8-10: **Each of us drew the same subject, but our strokes were unique, making every drawing a different and distinctive style.***

Figure 8

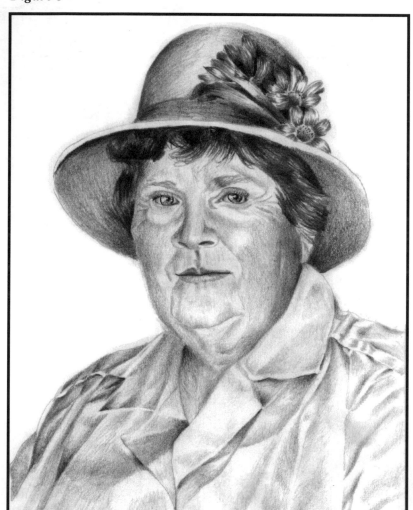

Drawing by Sandra Angelo

Figure 9

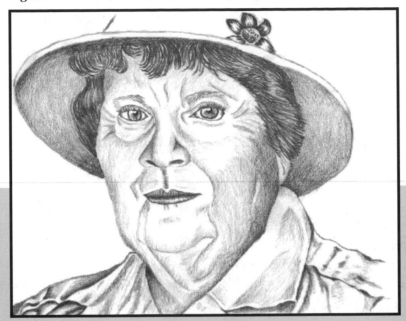

Drawing by Grace Igasaki.

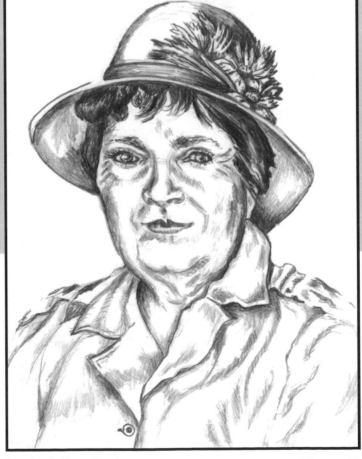

Drawing by Nancy Kearin

Figure 10

Paper

There are a wide variety of papers available on the market, most of which are bound in sketchpads. The quality varies dramatically and, unlike pencils, quality does not always correlate with price. Some excellent papers are very reasonably priced while some terrible papers are the same price as the good ones. Shopping for a good paper can be quite confusing. Almost every tablet will say its suitable for drawing, even if it isn't, so I made life simple for you.

Good news... your sketch pad is bound into this book. To save you the trouble of guessing which brands would work for these exercises, I bound good quality paper into this book so that you can use it as a workbook and sketch book. If you run out of paper, you can use the order form in the back of this book to send for my special sketch pads. In addition, most of the exercises I recommend require gridded paper so I made it easy for you by drawing the grids right on the practice paper in your book.

Caution! Soap box ahead. (This is where I get up on my podium and lecture about the importance of using good supplies 'cause I don't want to hear your whining when you get bad results using crummy stuff.) I recommend that you do all your exercises right on the paper in this book. Some people, who want to conserve their paper, will try to draw these exercises in other sketch books. This will defeat the whole purpose of why this book was created. I carefully selected the correct paper for you. If you choose your own paper, you might select lousy paper, 'cause you don't know how to choose a paper. Then you'll get bad results.

> **T I P**
>
> When you draw with the graphite pencil, your paper needs a 'tooth' or 'bite' to it. This means it needs to have a slightly rough texture so that the graphite will chip off and become deposited into the microscopic grooves of the paper. (To understand this better, remember when you tried to use a pencil to write a mushy poem to your favorite beau on the back of a slick greeting card? The pencil wouldn't stick because the paper was too slick(or maybe your verbage was too mushy). That surface is considered a plate finish and it has no 'tooth'. (Graphite pencils will only adhere to a paper with 'tooth'.)

Things that can go wrong...

You cannot get a full range of values with bad paper and, flimsy paper will pill (like a sweater) when you erase it. If you try to draw on a section you have erased, the graphite won't stick to your paper.

In addition, low quality paper will yellow and slowly deteriorate (Remember what happened last time you left the morning paper on the door step all day. The paper became discol-

ored.) You may want to frame a drawing, or at least save it. If you have paper that is disintegrating, you can't perserve it.

So to save you from your own well meaning frugality with its corresponding failure, I paid big bucks to bind good paper into this book. So use it already!

I have seen so many beginners waste time by using bad paper and cheap pencils. They are not doing the drawings wrong, it's just that they can't get the correct results with bad paper. Nag, nag, nag. I admit it. I have a fetish about using the right supplies. I get tired of the grumbling when people moan to me about their bad results, and it's all because they've used the wrong supplies. So, indulge yourself. Use good materials. (Honestly, the good paper costs exactly the same as the bad stuff. And if you use good quality, you'll save money in the long run 'cause you won't need nearly as much Maalox®.) Okay, okay, I'm climbing down off my soap box now.

ACCESSORIES

Dust Brush
Because graphite can get messy, you will need to purchase a dust brush to rid your paper of graphite residue and eraser crumbs. In my studio, I use a large drafting brush but on the road, I like to take along a goat hair brush. It's the perfect size and is nice and soft. (I prefer natural hair brushes over synthetic because they are gentle on the paper.)

If you can't find a goat hair brush, you can buy one using the form in the back of the book. Or you can visit Old Mac Donald and borrow one of his trained goats who will swish his tail over your paper on command. (Be careful to use the correct end of the goat. If the goat's head faces your paper, he will eat it, unless it's crummy paper; in which case, you'll wish he would eat it.)

Erasers
An inexpensive art gum eraser will work well to rid your paper of most mistakes. Although this eraser will crumble and smudge the graphite a little, it is the best at lifting large errors.

If you make a section a little too dark, you can gently lighten the area by pressing a

TIP

To keep your drawing free of smudges, use a piece of clean paper underneath your drawing hand. This will prevent your hand from picking up graphite and dragging it across your paper. I find that an 8x10 glossy photo with the shiny side down is the most effective shield because the slick paper will not absorb graphite.

kneaded eraser against that object. The kneaded eraser will stick to the paper and lift the dark values, leaving a gentle, soft gradation behind. (Other erasers leave an abrupt edge when they erase.)

My absolute favorite eraser is the small hand held, battery operated eraser because you can actually draw with it. It glides over the surface of the paper lifting the graphite rather than grinding it into the paper and crushing the tooth. To see how it works, look at Figure 11. I drew some grass and lifted out the highlights with my battery operated eraser. (As an aside, this eraser works well with other drawing media including colored pencils. About the only thing it won't erase is cellulite and wrinkles. Believe me, I've tried.) **Caution**: Beware of cheap battery operated erasers. They work fine till they hit the paper, then they stop. The best brand is on our order form in the back of the book.

There are other erasers out there, like pink erasers, plastic erasers and such but in my view these smudge too much. They skid in the graphite and create a little slurry which is very difficult to remove. Therefore, I limit myself to the erasers described above.

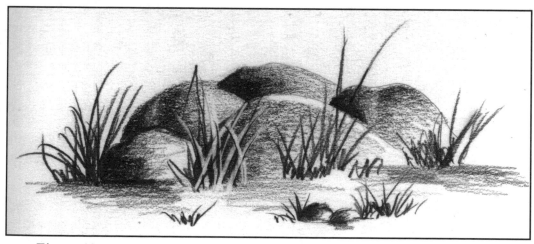

Figure 11

Pencil Cases
Believe it or not, pencils are fragile. The graphite leads inside the wooden casing will break if you drop your pencils on the floor. Then when you sharpen your pencil, the lead will break off into your sharpener. To prevent this, I carry my pencils and erasers around in a neat little case. (All artists with any fashion sense, have a different case for every outfit.)

Fixative
When you are absolutely sure that your drawing is perfect and you never ever want to change it, (i.e. if the Louvre just offered you $30 million for it), you can spray the draw-

Don't be confused by the term workable... that only means that you can draw on top of the fixative. Whatever is underneath the workable fixative is there to stay.

ing with fixative to seal it and prevent it from smudging. I always use workable fixative because I'm never really sure my client will like it that I drew all four of her chins. If I already sprayed the drawing with workable fixative, I can't remove one of the chins, but, I can add graphite pencil on top of workable fixative. So, I could change one of her chins into a turtleneck sweater. (If I had used a matte or glossy fixative, I could not add pencil because the surface would be too slick.)

Caution: Remember that fixative is very toxic. Whenever I spray it, I go outside and lay a weight on each corner of my paper. Holding the can 12-18 inches from the drawing, I lightly coat the paper using horizontal strokes. It is better to give the drawing several light coats, rather than one heavy one. A heavy application will cause the fixative to run.

Because I want to live a long time with my brain intact, I also take precautions so that I won't breathe the fixative. I wear a painter's mask from the hardware store while I am spraying and I close the windows and doors next to that spot. It only takes a few minutes for the fixative to dry but the odor lingers, so I set a timer and leave my drawing outside for 15-20 minutes. (The timer will remind you to retrieve the drawing before the scouts from the Louvre sneak up and steal it.)

Sharpeners

I use three different tools for sharpening. In my studio I use a vertical electric sharpener. For the road, I take along a battery operated sharpener and, to liven up a dull point between sharpening, I keep a piece of sandpaper close by. **Caution:** Avoid the cheap battery operated sharpeners which have simply taken a hand held sharpener and mounted it to a motor. Before you buy a sharpener, remove the casing where the shavings will be stored and look at the blades.

Be careful when you carry your battery operated sharpener around with you. If the casing for the shavings is not well attached, it may come off in your bag and leave a big mess. This problem can often be solved by simply wrapping a large rubber band around the sharpener to secure the casing.

CHAPTER ONE

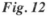 INSTRUCTIONS FOR GETTING STARTED *So where do I begin...?*

A Drawing System For The Artistically Challenged (Notice we didn't say klutz.)

There are many effective ways to learn to draw. Those ways have already been described in other art books. If they had worked for you, you wouldn't be reading this. So, what makes this system different?

Well, believe it or not, I actually started out teaching in high schools, ivy league prep

Fig. 12

Fig. 12 shows the dramatic improvement made by Bob Baker when he learned to draw by copying the techniques of the masters.

schools and universities. I was teaching a traditional art curriculum to naturally gifted students and my drawing lessons were so effective that I was even selected as one of the nation's top art educators for a Fellowship Award from Rhode Island School of Design. So I thought I could teach anybody. Wrong!

Much to my surprise, when I moved into adult education classes and found a room full of wanna be artists with no real talent, my tried and true, blue ribbon, award winning, traditional drawing lessons didn't cut it. No one understood a thing I said. I discovered that these folks learn in a radically different way. For one thing, they didn't even understand the language of art. Next, they were not inclined to deduce things on their own, they needed to be guided, and shown, step-by-step, with very specific instructions, until they eventually felt comfortable enough to venture forth on their own. So I threw out all of my prized techniques and started from scratch.

In this book I am presenting the results of a proven system that has worked for thousands of people just like you. I learned how to teach these new artists by listening. I listened to them describe the drawing process in their terms and I began to repeat it back. Over a period of years, I perfected this system by watching them and seeing what was effective and what wasn't.

That means there's more good news!

You are not a guinea pig! Many lab rats have paved your way so that you don't have to suffer.

Realize that everything will be presented in a step-by-step format, with a full explanation of the tools you will need and how to use them. While the world will not come to an end if you use the wrong pencil, you will probably get different results with other types of pencils. The whole system is predicated on the assumption that, if these exact methods and tools worked for thousands of others, they will work for you too.

The reason I tell you exactly what to use is because my rank beginners have begged for that format. To those of you who may have one recessive artistic gene, you may feel beginning twinges of rebellion when I tell you exactly what to do. To you, I say, 'If you are getting equal or better results doing it a different way, go for it'. The rest of you really

should follow this book step-by-step in the exact sequence presented, using the same pencils and papers I describe, or else you won't get the dramatic improvement most of my students have experienced. For those who are not naturally artistic, it's usually best to stick to the lesson until you know the rules well enough to break them. (Most good art is made by breaking rules but only by people who learned the rules first.)

Tell your friends emphatically... 'No snickering, unwelcome advice, or disrespect.'

You are embarking on a private journey. No one invites people to listen to them practice the piano, or football, or the violin. Don't let people watch you practice. Your sketch book is private, off limits.

'Why?' you ask.

Everyone is an art critic. Very few people in America, except the very talented, have taken art in school, but that doesn't keep them from being a 'know it all'. They often come up with very thoughtless comments that may sting, wound and discourage you, and all along they were just 'kidding' or 'trying to help'. The rank beginner has a very fragile ego. Most rank beginners don't really believe they can learn to draw in the first place and all it takes is a few of those snide comments to conjure up humiliating memories of art class.

This sketch book is your practice field. If you think someone is going to be critiquing your work, you will be more hesitant to relax and make mistakes. This mind set will keep you out of the creative right side of your brain. So keep this sketch book to yourself. Later, after you've finished this course, you can show everyone your finished pieces... but only show your best work. Believe me, you don't want to hear about the rest!

THE MAGIC DRAWING SYSTEM ...

Most traditional art teachers set up a still life or a model in the middle of the room and say, 'Draw'. New artists don't have a clue where to begin. 'Where do I start ... with the eye, the elbow, the ear...? How do I make a three dimensional object on a two dimensional piece of paper? What type of stroke do I use to draw hair? '

To beginners, drawing from live models feels like starting school in 12th grade. Since I believe it's too difficult for a rank beginner to draw objects from real life, I am going to take you back to the easiest form of drawing and present you with a graduated level of difficulty.

• Level One - Copying the Masters

"Stop right there!" you say. "It's cheating to copy." Well, guess what? Everybody's cheating then. Golfers copy Tiger Woods. Pianists copy Van Cliburn. In the Degas wing of the Norton Simon Art Museum, there is a Raphael painting, copied by Degas. If that's the way all the masters did it, guess what? It's legit.

Copying is the easiest form of drawing. It's easy because the drawing is already two dimensional. The artist has already solved the drawing equation, determining the texture of the strokes, the darkness and lightness of the marks, and the direction of the lines. All you have to do is copy.

What do you gain by copying? First, every time you draw, you are developing hand eye coordination. Next, you learn how to create textures, how to shade, how to draw eyes, how to simplify millions of tiny hairs to suggest the style rather than detailing every hair, etc. As with the art of calligraphy, as you copy, you improve your strokes. (Don't be worried about losing your own creative style just because you're copying. Copying good penmanship never made anyone lose their own handwriting. It simply improves your technique.)

Figure 13: In just five weeks, Gordon Kleim improved his drawing skills dramatically by copying the drawings of the masters.

When do I stop copying?

I recommend that beginners copy the masters until about 80 % of their drawings are turning out well. (Like high jumping, you don't raise the bar till you've been clearing it frequently.) Success breeds success. Stay with the easy things till you get good at them. The confidence you build, will help you gain courage to try the next level. Beginners need a lot of success to keep motivated. If you try things which are too difficult, you will experience a lot of failure. Repeated failure makes most people discouraged and then they give up. Wait till you are succeeding regularly before moving on to Level Two.

• Level Two - Copying From Photographs

Ah ha! Cheating again. Among the myths that surround art, is the belief that it is more noble and pure to draw from real life than to copy from a photo. Why? Because that's the way the masters did it! Do you know why the masters didn't use photos? Because they hadn't been invented!

Since the public expects artists to draw from life, many modern artists try to hide the fact that they use photos. I once read a book where an animal artist was actually claiming he never uses photos, yet his paintings had subjects like a lion leaping through a flying

cloud of dust, chasing a terrified zebra. Right. And I have some great swamp land in Florida.

Photos are fabulous for artists because they trap light, action, a glance, an innuendo, a frisky kid and other stuff that just moves too much. While artists are not slaves to photos, most use a combination of photos and live objects. Photos are a modern tool, so use them. Nobel prize winners use computers, even though the masters used a quill dipped in an ink well. 'The times they are a changin'.

Why is it easy to draw from a photo? Because it is already two dimensional. And, black

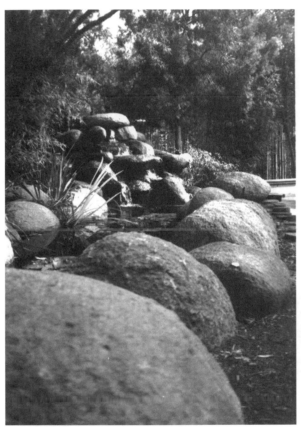

Photo by Sandra Angelo

Fig. 14 & 15 —Drawing from photos is easier than drawing from real life because the object has already been reduced to two dimensions and the values are clear, (meaning it is easy to see the light and dark patterns). Drawing by Gré Hann.

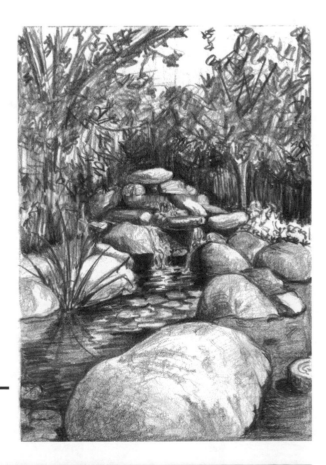

and white photos have already solved the value (that means light and dark) equation, and they can be gridded. (Grids will be explained later on page 25.)

So, once you've graduated from copying masters, begin working from black and white photos. Here, for the first time, you will have to solve the drawing problem. You must decide what kind of strokes to use for the hair, what direction your lines should take when drawing a nose... etc.. I will guide you through this and you will draw on the techniques you learned from copying the masters. After you've reached the 80% success level copying from photos, move on to level three, copying from real life.

• Level Three - Copying from real life.

Now you are ready for the level where most art classes begin, drawing from life. This is hard. Not only do you have to determine the direction of your strokes, but now you must learn how to translate color into black and white, and how to draw a three dimensional object on a two dimensional surface without making it look flat. This will probably be your most difficult transition. However, your practice will have taught you hand eye coordination, how to measure proportions, how to shade and how to create texture. Don't be surprised if it takes a little longer to master this level of drawing.

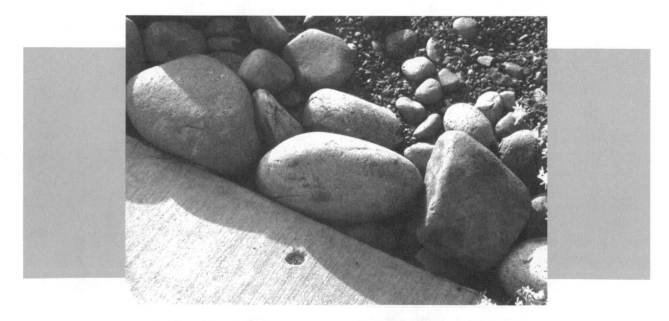

Fig. 16 — When you begin to draw from live objects start out with simple shapes and as your skills improve, increase the level of difficulty.

• Level Four - Composing original, creative art.

A lot of people think that all artists can draw anything out of their head. Surprise! It's not true. In teaching literally thousands of talented, creative, non-talented, and other assorted species, I have discovered that only 5% of talented artists can draw from their imagination. All others use live models, photos or a combination of the two. So if you can't draw out of your head, join the 95% ranks. (Many artists who can draw out of their heads are cartoonists.)

But, even if you can't create imaginary objects and fantastical beasts, after you master your drawing skills and study a variety of media, you will be able to compose original drawings. You will learn how to combine a series of photos with everyday objects, change things around and mix them up until you have an original piece of art which expresses your thoughts and feelings. (You can learn all about that in my next book, *Exploring Colored Pencil*. In that textbook I've written two chapters called *Design Fundamentals and Composing A Drawing*. Those chapters will walk you through the creative process and teach you how to tap your creative skills. (*Exploring Colored Pencil* will be available in Jan. 1999.)

You've either got it or you don't...

To that, I say 'Balderdash!' That's silly. If you picked up a violin, and dragged the bow across the strings and then recoiled from the discordant sound, you would say, 'Naturally I sound bad, I've never learned to play'. But if your first marks with a pencil aren't brilliant, you don't say, 'I haven't developed the skills for expressing myself', you say, 'I can't draw'.

All you really need to be a creative artist is to learn the rules first. As with writing, you learn grammar, syntax, punctuation, spelling and such before you take a creative writing class. You can't write creatively if you don't know the rules. No one would understand you if you couldn't spell and punctuate. So it is with drawing. You must learn the basics before you can express yourself effectively. The lessons in this book will teach you the language of art. This book is like a preschool. Once you've mastered these concepts, you will fit comfortably in any traditional art classroom because you will now understand the language!

You are in for an exhilarating surprise! Learning to draw will liberate your creative mind and provide you with the skills you have wanted so badly, the skill to express yourself visually, whether you want to draw a picture of your boss's face on your dart board, draw yourself with thin thighs and two less chins, or immortalize the world's cutest grand kids for posterity.

So enough hoopla already, let's turn the pages and get started drawing!

Fig. 17 — Practical uses for your new drawing skills... Immortalize your grandkids.

CHAPTER TWO

LEARNING TOOLS

DRAWING WITH A GRID

Artists see the world differently than you do. The key to drawing like an artist is beginning to see the world as they do. They see objects in terms of five key elements: shape, line, value, texture and color. In the following lessons, you will complete exercises which deal with the first four elements. (Color theory is so involved it will require a whole different book.) The lessons in this book will center around the four elements of shape, line, value and texture.

Learn to see shapes.

Artists see objects as a collection of shapes. When a subject is viewed as a series of interlocking jigsaw puzzle pieces, it becomes much easier to draw it . Look at the two drawings on page 26. In Fig. 18, the space between the man's arm and body is much easier to see because it is enclosed. The space outside his elbow is nebulous and difficult to draw. Look at what happens in Fig 19 when we put a vertical line next to his elbow? Now that the space outside his elbow is enclosed, it is much easier to read as a shape. If you were to draw the two shapes, the shape behind the elbow, and the shape between the arm and the body, you would have an accurate drawing of the arm.

This type of drawing is called negative space drawing because you are drawing the space behind the object, rather than the object itself. Looking at the background will cause you to draw more accurately. If you look at the subject itself, you tend to glance at it and then look down at your paper for several minutes, drawing from your stored memory about the object rather than drawing what you actually see. When you look at the background space instead, you have to stare at it closely, because the shapes are more nebulous and you can't remember them long enough to draw from memory. Drawing negative space forces you to really pay attention, instead of drawing from memory.

Look at Figure 18. Your natural tendency would be to draw the arm as if the hand was

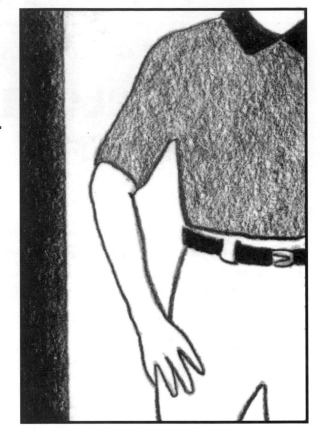

Figure 18 — The space between the man's arm and body is much easier to see because it is enclosed.

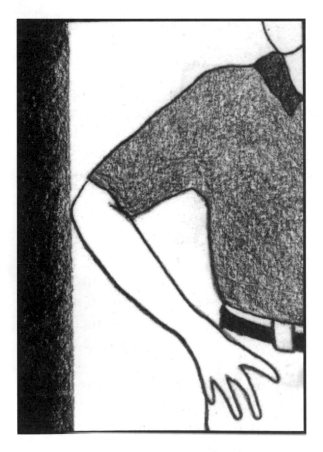

Figure 19 — When we put a vertical line next to his elbow, the nebulous space outside this man's arm is easier to see. If you draw the shape behind his elbow and the shape between his arm and his body, you will have a more accurate drawing of the arm. You will improve your drawing accuracy if you can draw the shapes behind the object, instead of looking at the object itself.

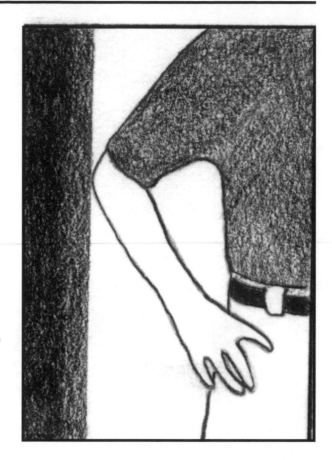

Figure 20 — Look at the background space between the body and the arm. Compare this space to Figure 18. Noticing the difference between these two shapes will help you draw the arm accurately.

placed at the waist. But if you look at the negative space, the space behind the object, you can see that the shape between the arm and the body in Figure18 is much different than the negative space in Figure 19. Looking at an object as a collection of shapes helps you focus on what you are really seeing rather than focusing on what your brain remembers about 'arms on the hips".

If you can learn to draw objects by viewing them as a collection of jigsaw puzzle pieces, you will be more likely to draw accurately.

Using The Grid...

Many artists use a grid of vertical and horizontal lines superimposed over their photo reference in order to see shapes precisely. Remember when we placed a vertical line next to the man's elbow? This helped us to see the shapes more accurately. A grid is simply a collection of vertical and horizontal lines. As we relate each shape to its adjacent vertical or horizontal line, we will find it easier to draw.

Okay here we go again. All of you skeptics are chanting,

'Isn't it cheating to use a grid?'

Time to burst another myth. The masters of old used grids. Look at the two drawings in Figures 21 & 22. One is by Leonardo Da Vinci and one is by Edgar Degas. Even

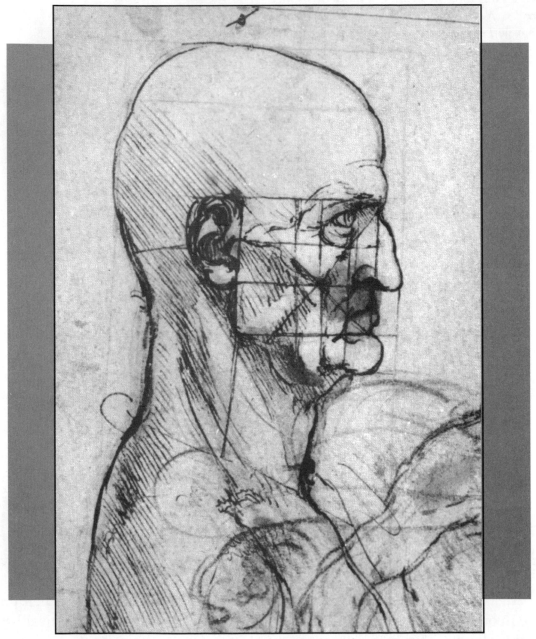

Fig.21

Figs. 21 & 22 — Look at these drawings done by the great masters. Leonardo Da Vinci, and Edgar Degas used a grid. If it's good enough for Ed and Leo, it's good enough for you.

Fig. 22

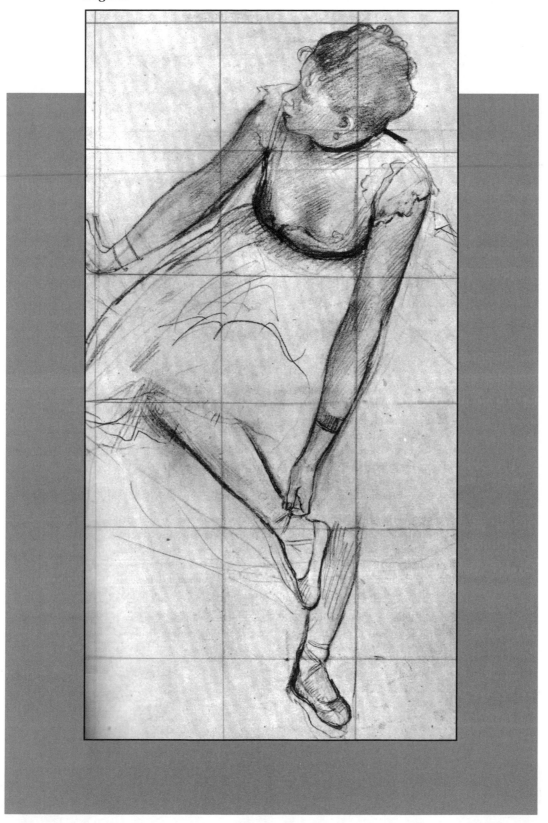

Michelangelo used a grid for the Sistine Chapel. If using a grid was good enough for Ed, Mike, and Leo, shouldn't it be good enough for you?

Three reasons to use a grid...

First, as we stated before, placing a vertical or horizontal line next to our subject will help trap the negative space and allow us to view it more accurately. Second, the grid helps us with proportions. In Figure 23, notice that the man's right eye is lower than the left one. In Figure 24, we have inserted a horizontal line to help us to see that the eyes are at different tangents. Without this line, we would probably look at the man and say to ourselves, 'Self, the man has eyes. Eyes are directly across from each other.' Then we would proceed to draw eyes like the man in Figure 25, wondering all along why he looks so weird. Using grid lines as a reference, we are more likely to place things accurately.

The third use for grids is enlargements. Michelangelo used a grid to enlarge his paint-

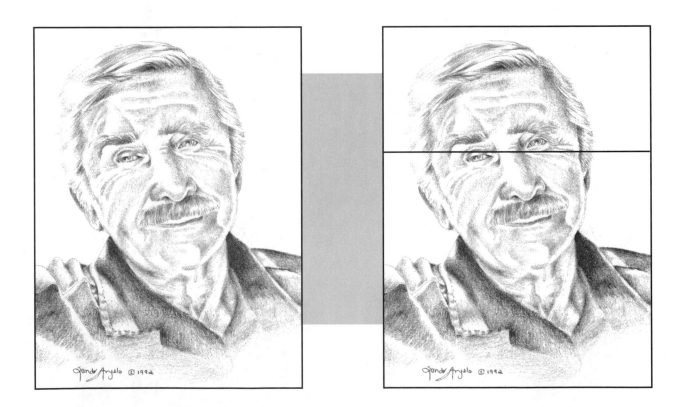

Figure 23 — Notice that the eye on the right side of the drawing is higher than the left.

Figure 24 — When we place a horizontal line at eye level, it becomes more evident that the eyes are at different heights.

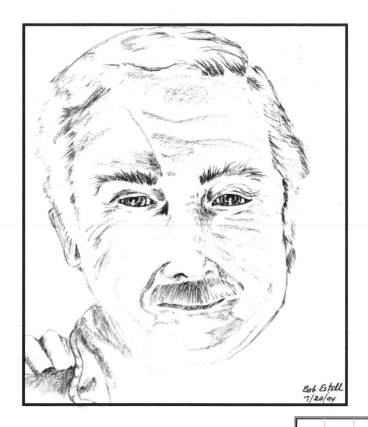

Figure 25 —If we glanced at the man, and then relied on our stored memory about eyes, we would tend to draw them both at the same level, even though that's not the way they really are. This student, Bob Estell, first drew the man without a grid. He was operating on stored memory that eyes should be at the same level so that is the way he inaccurately drew them.

Figure 26— When he redrew the man using a grid, he realized that the man's head is tilted, making one eye lower than the other. By following the grid, he was able to place the eyes more accurately.

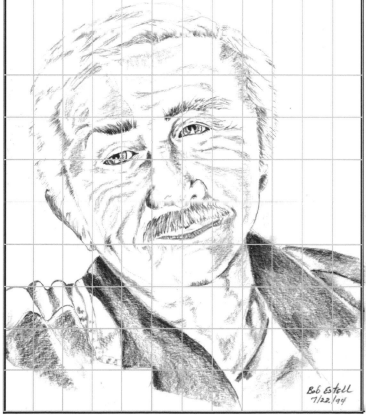

ing studies for the Sistine Chapel. When you are painting a ceiling, you can't back up to gain perspective. He had to break the subjects into a collection of modules so that he could retain the accuracy of his paintings.

How do I use a grid?

Because all of the practice pages in this book are gridded, you won't need to buy or make a grid kit to complete your lessons. However, after you've finished this book, you may find you need to continue using a grid for awhile. If so, here are the instructions for making a grid.

Option One: Draw lines on your drawing paper with a ruler and a light pencil. Make sure the boxes are always square. Rectangles don't work... (don't ask me why, this is not a geometry class now is it?) With the thin end of a black Identipen draw lines on top of your photo reference and label the grid boxes the same on both your paper and your picture.

Option Two: If you are too lazy to make your own, buy our grid kit listed in the back of the book. It has three acetate sheets with different size grids and grid paper to match. Paper clip the acetate over your photo reference, creating an instant grid. (This also prevents you from having to damage the photo by drawing lines on it.) Lay your grid sheet underneath your sketch paper and paper clip it in place. If you are using our sketch pad, you should be able to see the grid lines through the drawing paper.

How do I know what size grid to use?

Most people can get by with just a few sizes of grids. A one inch grid and a one half inch grid should suffice for most drawings in this book.

The grid size will be determined by the size of the object you are copying. In Figure 27 you can see that a one inch grid is perfect. In Figure 28 a one half inch grid was needed because of the size and complexity of the subject.

Note that you can also use a large grid for the majority of the subject and then subdivide the areas which have more complex details. See Figure 29.

Identifying Tangents

Many students find it useful to place a series of letters across the top and bottom of their grid, and a series of numbers along both sides of the grid. This will help you identify which square you are drawing; i.e. 'B 2' in Figure 27.

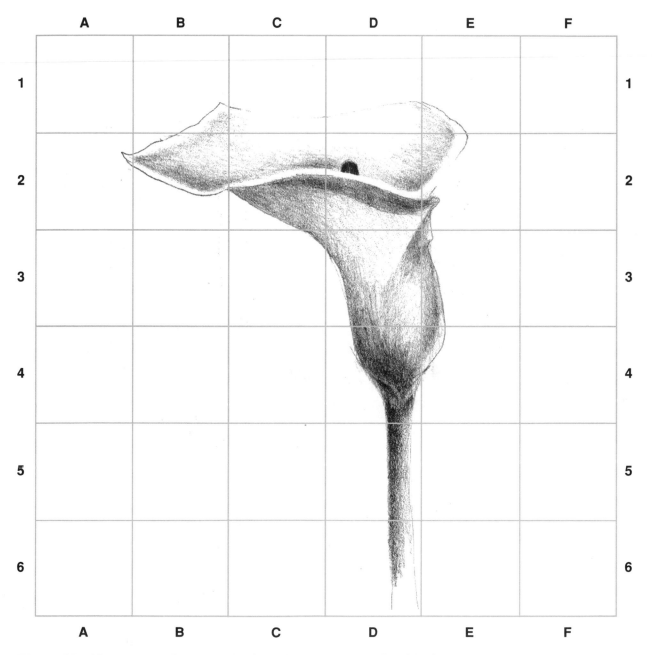

Figure 27—You can see that a one inch grid is appropriate for this drawing.

Drawing by Sandra Angelo

Aaargh! Will I ever outgrow the grid?

Yes. Calm down. Put the sedatives away. You will outgrow this stage. When you were first learning how to ride a bike, you needed training wheels until you learned to keep your balance. A grid is like training wheels. You need vertical and horizontal lines on your page until you begin to see the shapes without them. Eventually you will see objects as a collection of shapes. At that point, you will know you've outgrown the grid.

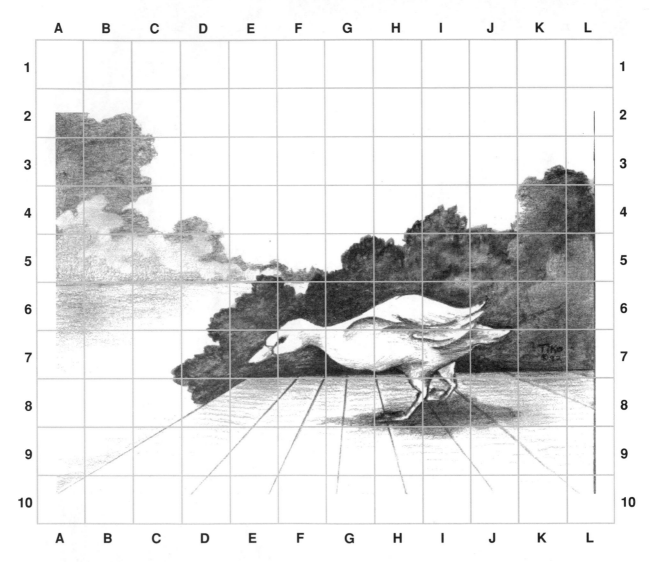

Figure 28 Because of the complexity of the details, a smaller 1/2 inch grid was used over this photo. Drawing by Tiko Youngdale.

However, you will still revert to using an occasional vertical or horizontal line here and there when you are trying to conquer problem areas. That's why Leonardo Da Vinci slapped a grid on the nose. (See Figure 21 on page 28) The face was a piece of cake but that snout was a real bear. The grid helped him resolve the problem.

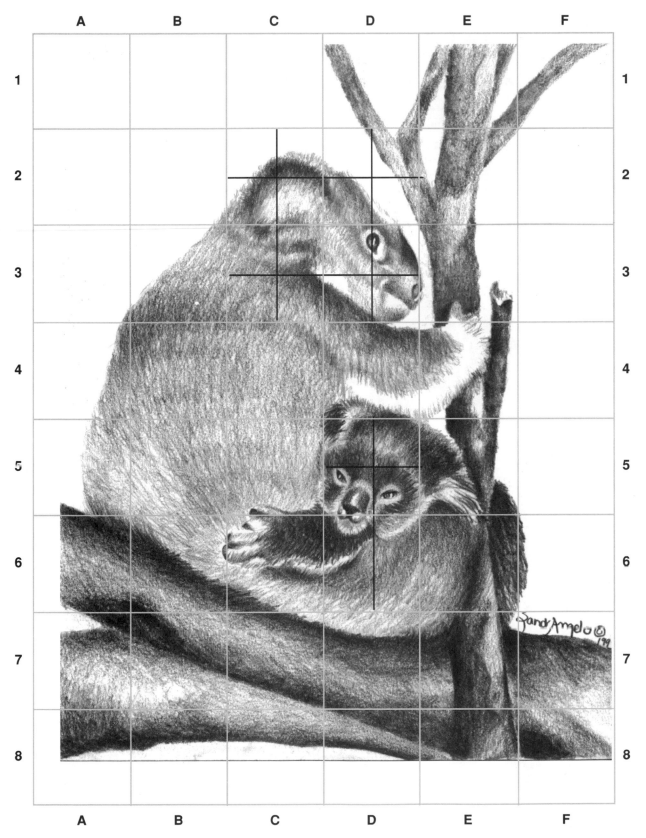

Figure 29— In some cases, you may use a larger grid for the majority of the photo and then subdivide the areas which have more complex details.

NEGATIVE SPACE DRAWING

CHAPTER THREE

SEEING SHAPES

You will be surprised at how much easier it is to draw things accurately when you begin by drawing just the silhouette while looking at the negative space behind the object. Because our brain stores preconceived notions about objects, we tend to rely on our memory about how these objects should look rather than paying close attention to the angle or perspective in front of us. For example, our brain stores the eye as an oval with a circle in the middle like Figure 30. Look at the eyes in Figure 31 and 32. You can't see the full circle can you? Notice that the three shapes in the eye in Figure 31 are very different than the three shapes in Figure 32. If you drew these eyes by looking at shapes, instead of drawing what you remember about eyes, you would draw more accurately.

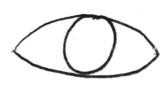

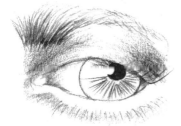

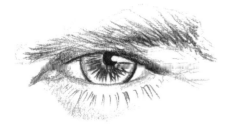

Figure 30—This is the way we think of an eye; an oval shape with a full circle in the middle. If you look at the eyes in Figure 31 and 32, you will see that you cannot see the full circle of the iris. Looking at the eye as a collection of shapes will help you see it more accurately.

Figure 31—Look at the three shapes contained within this eye. The white of the eye on the left is so much bigger than the white space on the right. If you drew these two white shapes and the iris, you would have an accurate eye.

Figure 32—Notice how different the white shapes are in this eye when compared to the shapes in Figure 30.

Drawing negative space is especially helpful when we are trying to draw objects which are foreshortened. Foreshortening means that an object is pointing straight at us. Look at the rhino in Figure 33. His body is coming straight at us. His head, which is in profile, would be easy to draw, but the rump, which is foreshortened, is tough. If we focused on his body while drawing, we would have a terrible time drawing him accurately. However, if we concentrate on the shapes around him (the negative space), as we did in Figure 34, we would be much more inclined towards accuracy.

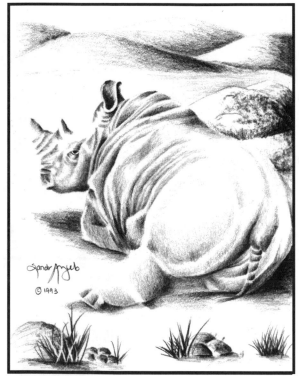

Fig. 33

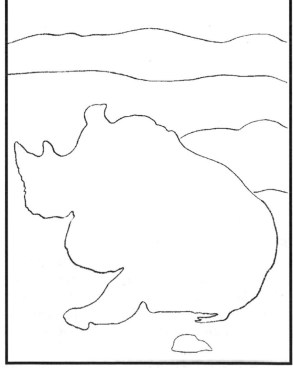

Fig. 34

Instructions For Exercises

We learn to draw the Old Fashioned Way, *we practice*.

Here's a list of general instructions for all the exercises in this book.

One: In Chapters 3 and 4 I've provided a space to try the drawing with the grid and without the grid. Do both drawings. If your drawings are consistently accurate when you don't use the grid, you may not need it. If you don't need the grid, copy the drawings from this book in a sketch pad, (because sketch pages would not be gridded). Most of you however, are rank beginners and will need a grid. You should practice all of your drawings on the gridded paper provided in this book.

Two: We learn to draw the old fashioned way, we practice. If you want to redo any of the drawings, you can use a grid kit and practice the same piece over and over again in your sketchbook, until you are satisfied with the results. While it is very useful to practice the same piece twice or even three times, it's a good idea to complete most of the drawings in the book before going on to repeat them. Don't expect perfection. You are like a first grader ... very new at this. As you continue practicing, your skills will improve automatically.

It's not a good idea to do a lot of erasing. Just draw each subject to the best of your ability and turn the page and draw the next one. You'll be very surprised that some of your drawings will turn out well and others may be a tad worse. You'll find that when you are drawing a subject that you like, you will draw it well, even if it's difficult. Consequently, it's a good idea to start with drawings that look easy and fun. Once you meet with success, you'll have the courage to tackle more difficult subjects.

Three: The tortoise and the hare... remember who won? Take your time with the exercises. Don't compare yourself to others. There is no correlation between speed and talent. New artists who will end up becoming Impressionists generally work faster and those who will be Realists generally work slower. Work at your own speed and don't be pressured to keep up with others. It's better to take your time and make sure you master each concept before moving on.

Four. What does chocolate ice cream have to do with this?

You need to keep a visual record of your progress so that you can see how you are improving. Your drawing will improve very slowly, but just like gaining weight, you will not notice gradual changes. I have this on good authority because I've done the research. I ate just one bowl of Chocolate Chocolate Chip Haagen Daas ice cream every day for three months. I really couldn't see the difference until I looked back at a picture of myself in the beginning stages of my research. My figure had definitely changed. Your work

will change too, but the improvement will be very gradual. If you keep each drawing, you will be able to see your progress. Looking back at your early drawings will encourage you.

So, when you make a mistake, try to resist the urge to rip, slash or tear your drawing out of your book and feed it to your ravenous paper shredder. I know it will be difficult, but, if you exercise some restraint, you will be gratified by a visual version of your progress. For example, by the time you get to Chapter Six, you may not feel like you have made any improvement, yet when you look back at the drawings in lesson one and two, you will be amazed at your progress.

In addition, you will often learn a lot from reviewing your first drawings. As you progress, looking back at your old drawings will help you see the importance of using the new principles you have just learned.

Five: As a general rule, it is easier for beginners if the drawing process is broken down into simple steps like the drawings in Figure 35 on page 41. Many beginners find it useful to follow a four step process.

First, begin each drawing by putting in the negative space. Then, inside the same negative space, do a line drawing, which will serve as road map for your shapes and shadows. Next, shade the object to establish the light and dark values and finally, on top of this, place the textures or details. In this revised edition, I have provided negative space and line drawings of many of the exercises.

Six: Some people learn by reading and others are visual learners. Reading learners may be able to acquire all the skills they need by simply reading this book and copying what they see. Visual learners will find it helpful to supplement this book with the companion videos. The videos will allow you to watch my hand up close while I draw and see how I make my strokes, how hard I press, when I turn the paper, etc. The three companion videos for this book demonstrate several of the drawings in this book. They are *Drawing Basics, The Easy Way To Draw Animals* and *The Easy Way To Draw Flowers, Water and Landscapes*. (See the back of the book for ordering info.)

Seven: Because most people who buy this book are time conscious, I have broken the exercises down into a set of bite sized lessons. If you want to follow a regime, simply complete one drawing per day. Most folks can complete the entire book within 90 days if they practice 45 minutes to one hour each day. As your work improves, you'll find yourself looking forward to this refreshing hour each day. Art has tremendous therapeutic values. You'll be surprised how fast time flies when you are drawing and how refreshed you will feel afterwards.

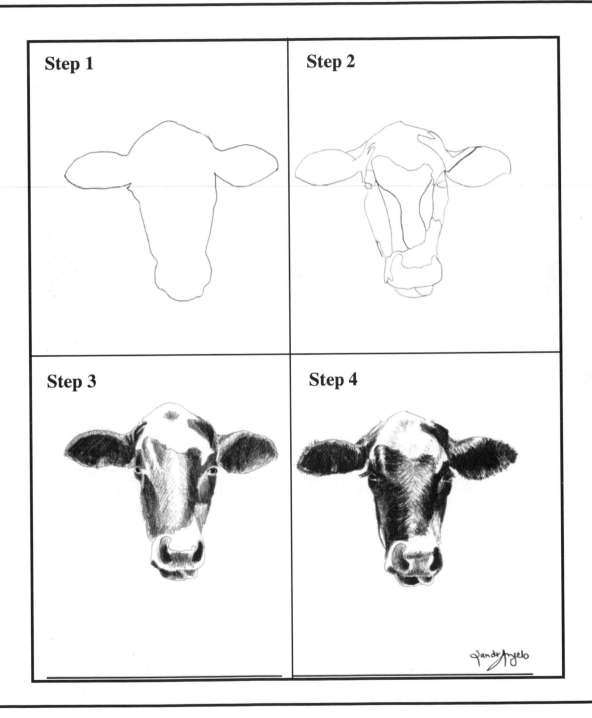

Step 1

Step 2

Step 3

Step 4

Figure 35 —This progressive drawing of the cow shows the four step process that most beginners use. First the negative space is established, then the contour lines are added, next a study of the light and dark values is completed and the textures are put on last.

Shape Exercises
(Aerobics for artists)

> **T I P**
>
> When you draw with a grid, concentrate on one square at a time. As a general rule it is best to start with the section which looks easiest to you. That way, your success will build confidence quickly and you will be ready when you reach the tougher stuff.

If you are having problems with accuracy, think about using a drawing window. To do this:

1) Use an 8 1/2 x 11 sheet of paper (or one side of a manila file folder, because it's sturdier than paper).

2) In the center of the folder, cut a square window that is the same size as your grid square, (i.e. If you are using a one half inch grid, you would cut a one half inch window in the middle of your 8 1/2 x 11 folder.)

3) Place this window over your drawing reference so that you can only see one grid square at a time. This will block out the rest of the drawing and force you to concentrate on only the square you are drawing.

You can peek underneath periodically to make sure you are in the right square, but you should not analyze your drawing or make corrections until you have finished the entire drawing. If you follow this procedure exactly, (without analyzing or correcting while you draw), you will be amazed at your accurate results.

Using a window can seem tedious but it is actually training you to see shapes, lines, and values just like artists see them. Soon you will see them without having to use the window. Like the grid, the window is a training tool.

Shape Exercise

In box 2, draw the negative space of the lamp with the grid. When you are doing this negative space drawing remember to focus on the black space while you draw. You will draw more accurately if you draw the space behind the object rather than the object itself. I have made this negative space black so that it is easier to identify it as a shape.

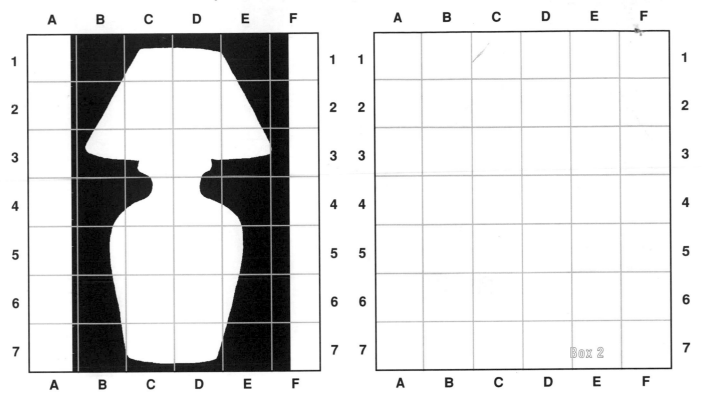

In box four, draw the lamp again, without a grid this time. Did you get more accuracy with or without the grid? If you were more accurate using the grid, you will probably need to use one for most of the lessons. If you did ok without it, try a few more without a grid. See which method gives you the most accurate results.

Shape Exercise

In the first box, you will see the object you are to draw. Do a negative space drawing of this object in the second box, using the grid. Then try drawing it without the grid in the box below.

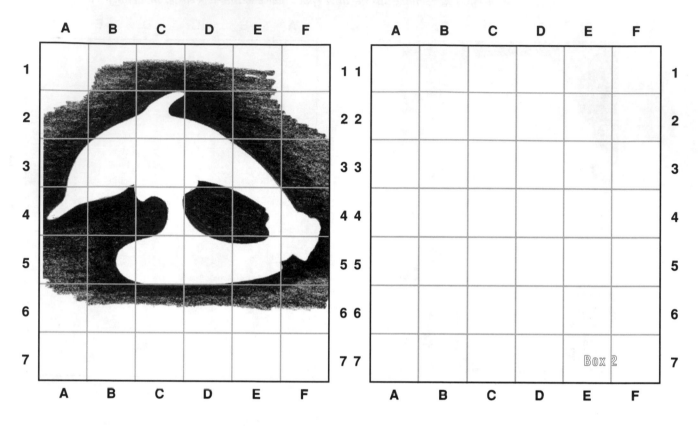

Try again, without the grid.

Shape Exercise

In the first box, you will see the object you are to draw. Do a negative space drawing of this object in the second box, using the grid. Then try drawing it without the grid in the box below.

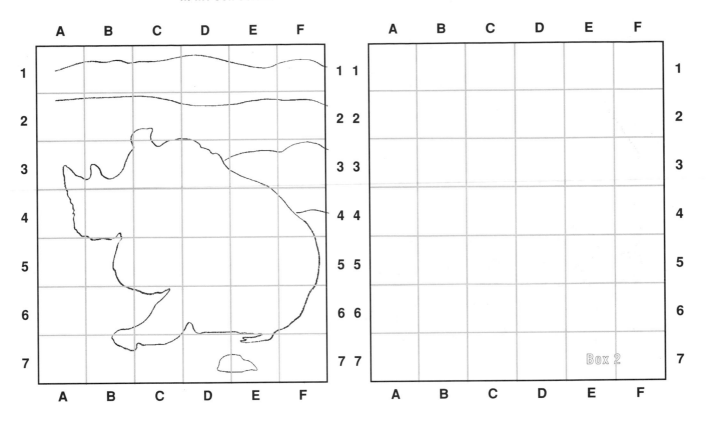

Try again, without the grid.

Shape Exercise

In the first box, you will see the object you are to draw. Do a negative space drawing of this object in the second box, using the grid. Then try drawing it without the grid in the box below. (It's okay to use a ruler.)

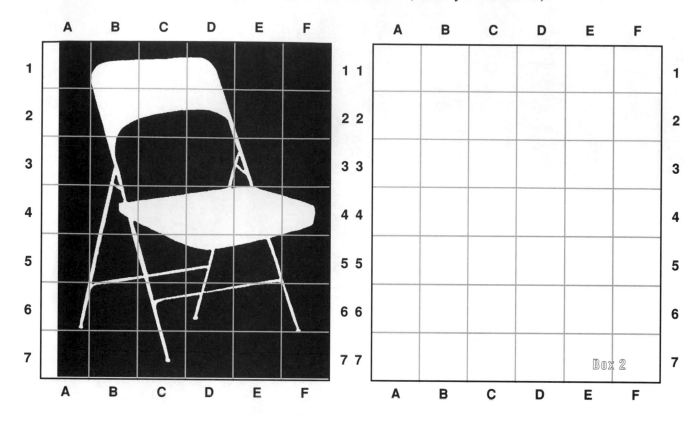

Try again, without the grid.

Shape Exercise

Now try doing a NEGATIVE space drawing by looking at the final drawing of the elephant. Remember to concentrate on the white space, not on the elephant. Draw only the silhouette.

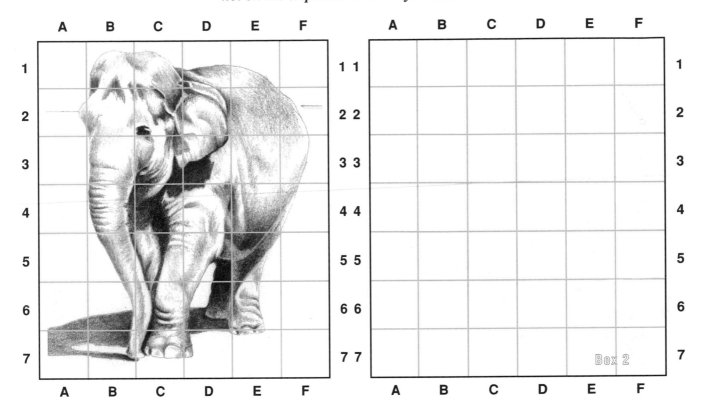

Try again, without the grid this time.

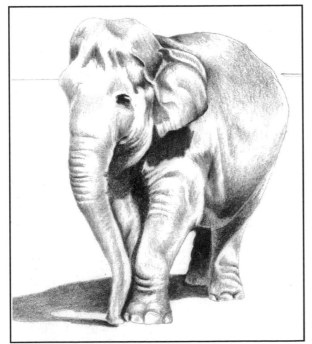

Drawing by Sandra Angelo

CHAPTER FOUR

CONTOUR LINE DRAWING

SEEING LINES

Most artists begin their drawing by laying down an elaborate map which dictates where they will place their shapes and shadows. Reducing an object to its simple line elements helps the artist solve the proportion and placement problems before shading. These drawings, which show both the interior and exterior lines of an object, are called contour line drawings. If you want to impress your friends, casually refer to your line drawings as a collection of contour line drawings. This sort of conversation makes for great reparteé over cocktails with your boss, a date, or anyone you're trying to amaze.

In Figure 36 you see a negative space drawing of the rabbit. In Figure 37 we filled in the interior contour lines. These lines will later serve as a map for placement of our interior shapes & shadows.

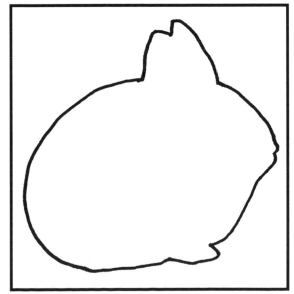

Figure 36

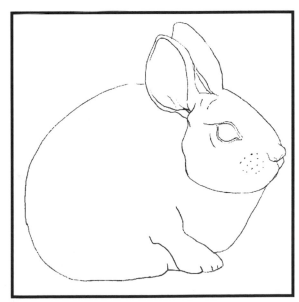

Figure 37

Line Exercises

In the first box, you will see the object you are to draw. Do a negative space drawing of this object in box 2, using the grid. In the same box, fill in the interior contour lines to establish a map for your shapes and shadows. Then try this same drawing without the grid in the box below.

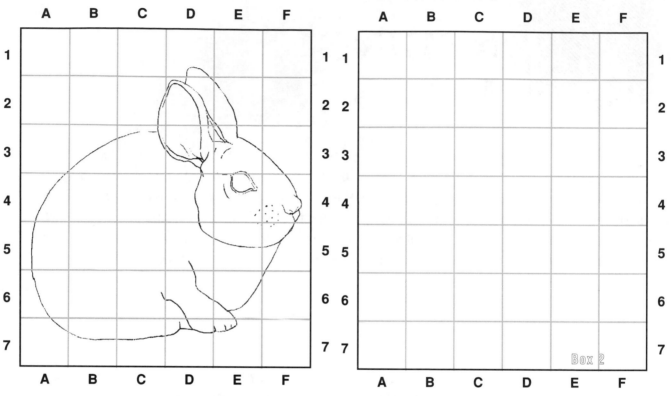

If you want to try the same drawing now without the grid, give it a whirl.

Line Exercise

Copy the contour line drawing.

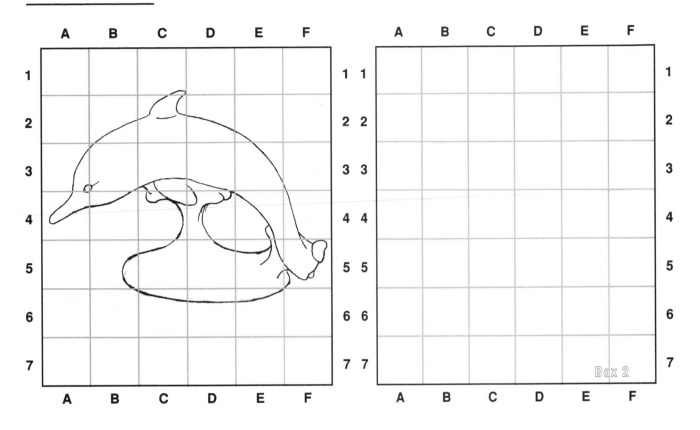

If you want to try the same drawing now without the grid, give it a whirl.

Line Exercise *Copy the contour line drawing.*

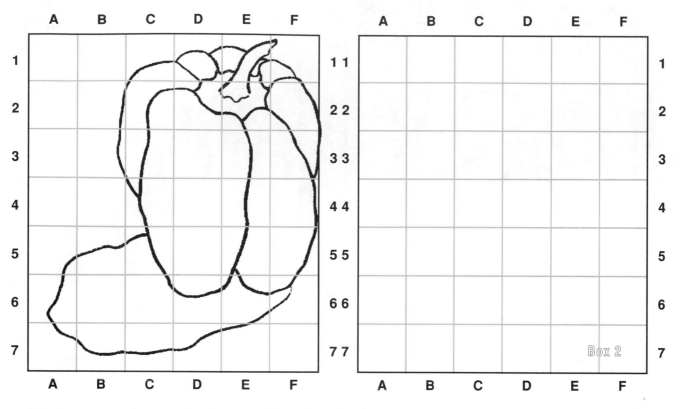

If you want to try the same drawing now without the grid, give it a whirl.

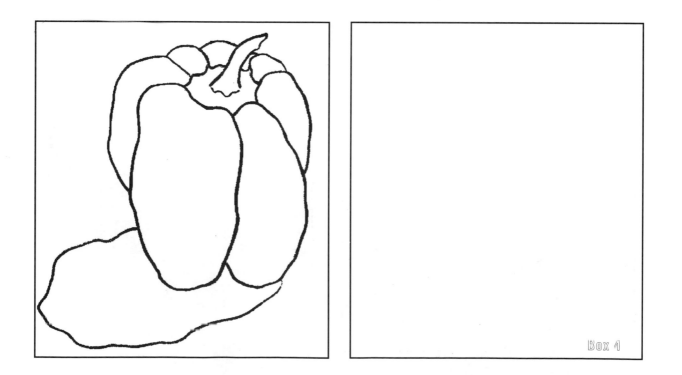

Line Exercise *Copy the contour line drawing.*

If you want to try the same drawing now without the grid, give it a whirl.

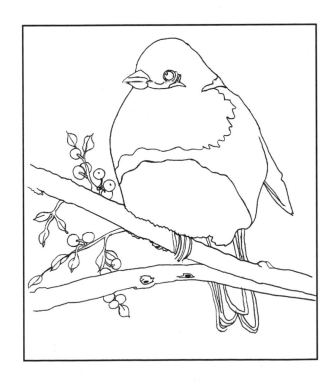

CHAPTER FIVE

VALUE DRAWING

LEARNING TO SHADE

In the art world, shading is referred to as a value study. To show the world how savvy you are, go around referring to shadows as deep values. Look into your loved one's baby blue eyes and say, ' What light values you have, my dear.' (If he responds, 'All the better to see you with, my dear,' beware!)

Learning to see the light and dark values in the objects that you draw is absolutely crucial because drawings and paintings with a full range of values have much more dimension and depth to them. Understanding how to create value will provide the foundation for all your future art endeavors. Or as my old crotchety art teacher, Mr. Dingleberry used to say, 'You need to take a second look at your values, honey.'

What do you mean you want to change my values..?

To avoid a rainbow effect like the one you see in Figure 38, go back over the section where values change and blend the two neighboring values together like the ball in Figure 39.

Figure 38

Figure 39

Photo by Sandra Angelo ©1989

Figure 40

When you look at the photograph in Figure 40 you will see that there are many shades of black, white and grey. Using a scale of one to ten, with one being white and ten being solid black, rate each shape and shadow that you see. If you can accurately draw these values the way they appear in the picture, your drawing will have depth and it will look three dimensional. If, like most beginners, you use all medium values, your drawing will look flat like the drawing in Figure 38. Look at how much more dimension there is in the drawing in Figure 39.

It is interesting to note that you will use this same rating system to determine your values even when you switch to color and begin painting with watercolors, acrylics, oils, pastels, colored pencils, and all other art media. That's why it is so crucial for you to learn to see every shape and shadow in terms of its value rating.

Shading Exercises

Are you afraid of the dark...?

Most beginning artists are terrified to draw dark values because they feel dark mistakes are much worse than light ones. As we just said, unless a drawing or painting has a wide range of light and dark values, it will look flat and lifeless. The most common mistake among beginners is the lack of depth in their values.

To learn how to use a pencil to create light and dark values, let's begin by practicing our value scales.

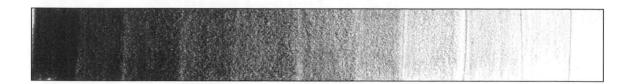

Shading Exercise

Instructions: Using your 3B or medium pencil, create 10 different values in the boxes below. You can copy from the value scale above.

Shading Exercise

Now try the same exercise with your 6B or dark pencil. I have provided several practice boxes so that you can keep trying this exercise until you get exactly 10 different values. You can copy from the value scale above.

T I P — To shade an object with even tones that gradually move from light to dark, use a shading technique called 'gradation'. Gradation simply means to shade without showing your lines. The easiest way to graduate your values is to move your pencil back and forth, blending the adjacent lines so that no texture shows. You can change the lightness or darkness of your value by pressing harder or lighter on your pencil. (When I graduate my values, I don't lift my pencil off the paper at all.)

CREATING DEPTH IN YOUR DRAWING

How do I make it look round?

There are four ways to shade which will create depth in your drawing.

One: If you use a gradual change in value from dark to light, your object will begin to look round. See the ball in Figure 42.

Two: You must have a wide range of values in your shading. Look at the ball in Figure 41. Because there are only a couple values, the ball looks flat. By contrast, the ball in Figure 42 has a wide range of lights and darks, making it look very round.

Figure 41 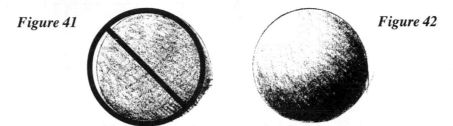 *Figure 42*

Three: Your pencil strokes should always follow the contour of the object. In Figure 43 the pencil strokes go every which way. The ball looks flat. In Figure 44 the strokes follow the contour of the ball. This ball is beginning to look round.

Figure 43 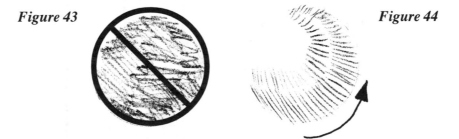 *Figure 44*

Four: If you place dark at both edges and light in the middle, your object will look round like the cylinder in Figure 46. In Figure 45 the cylinder only has one value so it looks flat. (Notice too that the bottom on the cylinder is flat while the top is round. This is the way most beginners draw cylinders. The correct way to draw a cylinder is to make sure the arc of the ellipse at the top of the cylinder is the same as the curvature of the ellipse at the bottom just like the cylinder in Figure 46.)

Figure 45 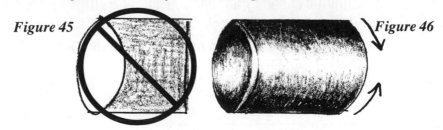 *Figure 46*

Instructions for shading exercises

Instructions: On the following pages, in box 1, you will see the object you are to copy. In box 2, using the grid, draw the negative space first, then in the same box, fill in the contour lines which delineate a map for shading. Next shade your drawing within the contour lines you have just established. Figure 47 demonstrates the sequence you will follow.

Now copy all the value drawings in this chapter.

Figure 47

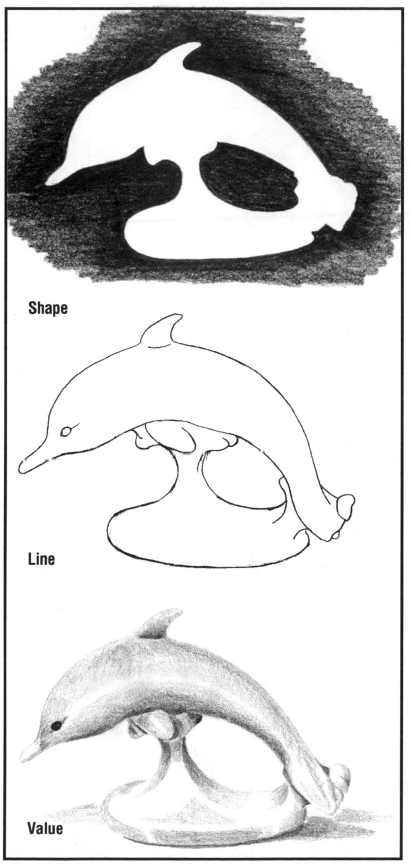

Shape

Line

Value

Drawings by Gré Hann

Although your lines don't show when you graduate your values, it is important to shade in the proper direction so as to sculpt the object with your lines. In box 1 you see a diagram which shows the line direction in each section of the green pepper. All shading should follow the contours of the object. Practice shading the pepper in the boxes below.

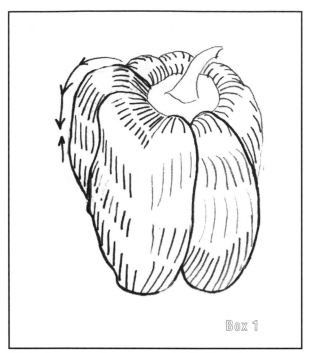

Box 1

Box 2

This diagram shows you which direction your lines should take when you shade the pepper

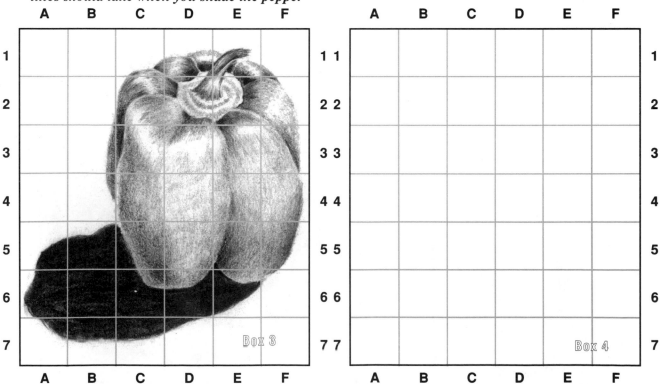

Box 3

Box 4

Value Exercises

Copy these drawings to learn shading techniques.

Value Exercises

Try these drawings on the practice paper. If it seems too hard, consider practicing just a few of the parts of the drawing. If the subject doesn't interest you, you can skip to the next drawing.

Value Exercise

Copy this value drawing in box 2 below.

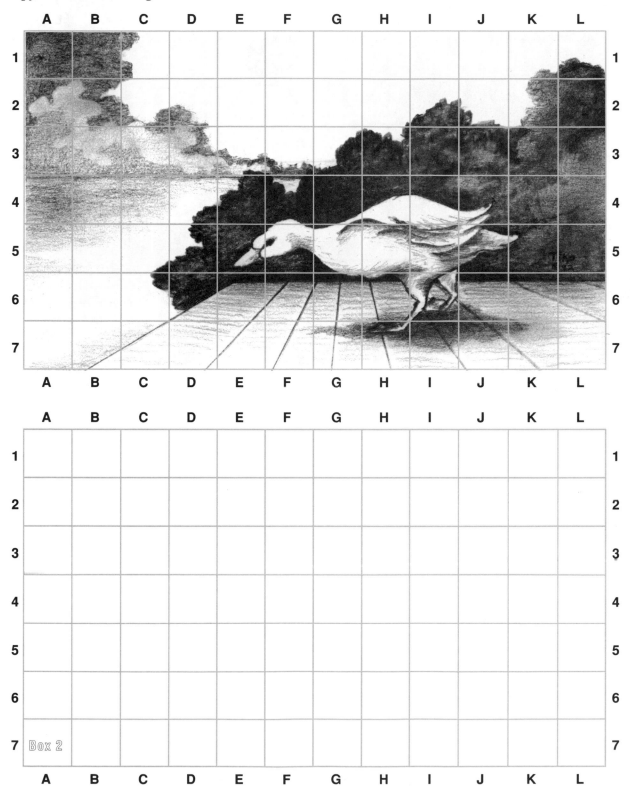

Drawing by Tiko Youngdale.

Value Exercise

Copy this value drawing in box 2 below.

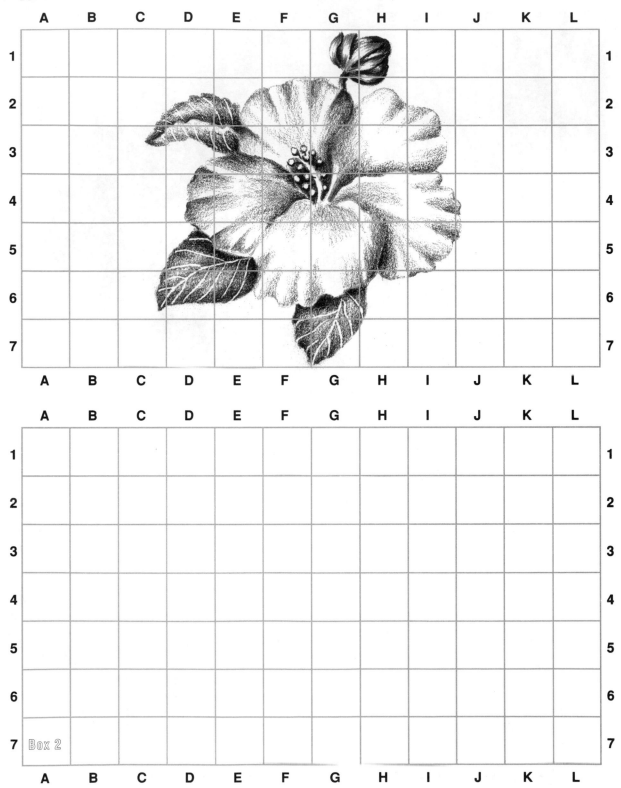

Box 2

Drawing by Sandra Angelo

Value Exercise

Copy this value drawing in box 2 below.

Drawing by Tiko Youngdale

CHAPTER SIX

CREATING TEXTURE

Fluffy flamingo feathers. Uncle Delbert's droopy jowls. Spido's cold wet nose. Dangling cellulite. Einstein's bad hair day. How do you create these various textures with the humble pencil?

Artists have come up with all kinds of elaborate strokes to simulate the textures they see around them, but the most commonly used textures are hatching and gradation.

Gradation: As we explained earlier, to graduate your strokes, use small circular marks, never lifting your pencil off the paper. Blend your strokes so that the lines do not show, thus creating a soft graduated value, i.e. the green pepper in Figure 48. As a general rule, this technique is used for objects that have smooth textures like the folds in fabric, saggy, baggy skin, a peach, a green pepper, a baby's cheeks, etc.

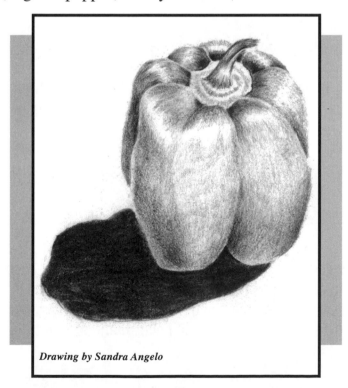

Drawing by Sandra Angelo

Figure 48

Hatching: To create hatching lines, lift the pencil off the paper with each stroke allowing your lines to show. To change the lightness or darkness of your lines, simply use light, medium or heavy pressure on your pencil. See Figure 49. Another way to change values is to space the lines farther apart for light values and place them closer together to make the values dark. See Figure 50. As a general rule, hatching is used for objects which have a linear texture like human hair, grass, needles on a pine branch, a shaggy dog, a fluffy cat, Uncle Mortimer's toupee, etc.

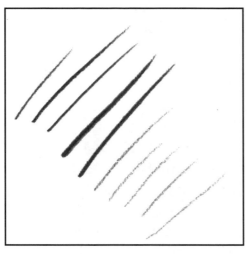

Fig. 49

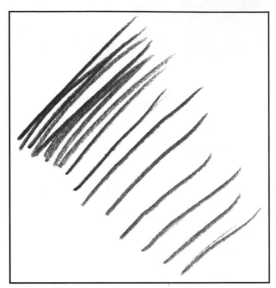

Fig. 50

Texture Exercise:

Practice graduating your values by shading the rocks on page 69. If you'd like, you may draw the negative shape first, then draw the contour lines, and finally shade the values with graduated strokes. Blend your lines so they don't show. This will simulate the soft texture of these boulders. Remember, to get a dark value, press harder, to lighten your values, ease up on your pencil pressure.

> **TIP** Never smudge your pencil lines with your fingers. Your B pencils (as in 2B, 3B, 4B...) will give you soft graduated values if you just keep going back over your lines, blending them gently. (The reason you have an impulse to smudge is because you are used to using the common HB household pencil. No matter how hard you tried, that pencil never blended unless you smudged with your finger.)

Shade these rocks with gradated values. Use hatching lines for the grass.

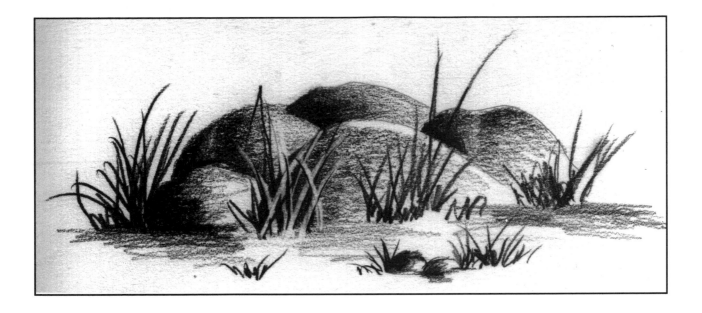

Now practice hatching by adding the grass to your rock drawing. Be sure to make your strokes go in various directions. Grass does not grow straight up. You can vary your values by changing your pencil pressure or by placing the strokes further apart. If you have a battery operated eraser, take out some of the dark values in the grass with the eraser.

Texture Exercise:

There are other ways to create texture. You can vary your pencil pressure, twist it, push it, lay it on its side, etc. On page 71, try playing with your pencil to see how many different textures you can create by varying your strokes. Underneath each texture, describe how you created that texture. Then write down some uses for that type of stroke. For example, in Figure 51 you'll see that I laid the pencil on its side to simulate the bamboo handle. I then used the point of the pencil to create the goat hair brush.

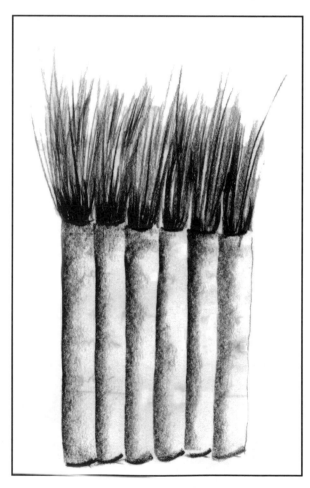

Figure 51: I used the side of my pencil to draw the bamboo handle and the point of my pencil to create the goat hair brush.

Look at the variety of textures I created by varying my pencil strokes. Next to my textures, I wrote down possible applications for these strokes.

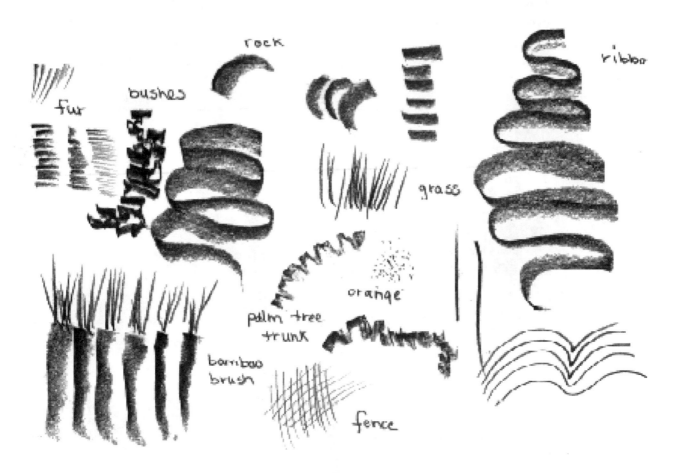

Now it's your turn. Fill this page with a variety of textures, using different kinds of strokes. For future reference, write down how you achieved each texture and ways you might use these marks in your drawings.

Begin to notice textures around you ...

Look at the four animals in Figures 52 through 55. Even though each of them have a linear hair pattern, every kind of fur has a different texture. Each animal's hair requires a different stroke. On the adjacent page, practice drawing each of these textures. You don't need to draw the whole animal, just do a little section and practice getting the appropriate texture.

Figure 52 *Figure 53*

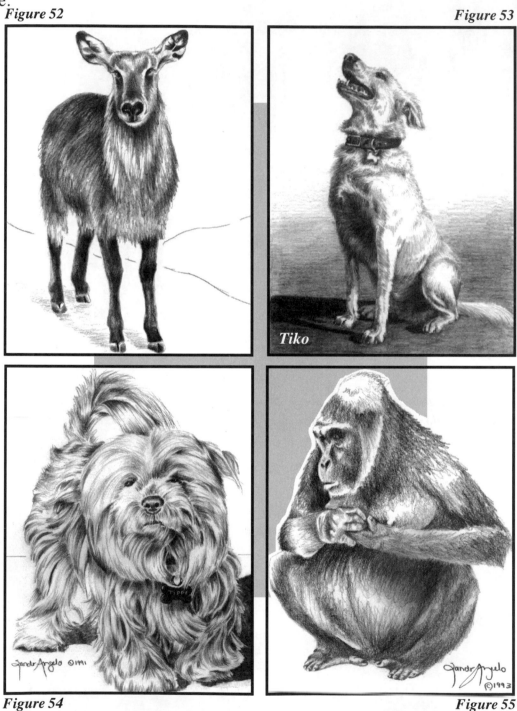

Figure 54 *Figure 55*

Even though all of these animals are covered with fur, the texture in each case is very different.

CHAPTER SEVEN

EXERCISE SECTION

TIME TO PRACTICE

Now you are going to practice texture by copying a wide variety of subjects. The following pages are full of drawings for you to copy. If you want to, you can use my four step drawing system for each of these drawings: 1) begin with the negative space 2) fill in the contour lines 3) shade the object and 4) apply the texture.

If you feel overwhelmed by any of the drawings, just practice parts of it, such as the tail, one leaf, one pumpkin, etc. After you practice the individual parts, you may be ready to tackle the whole drawing.

You don't have to do every drawing. Start with the ones which look easy and fun to draw. We all draw better if we are drawing something we like. An artist who loves landscapes may draw faces very poorly simply because she doesn't enjoy it. We all do best at what we love so stay with the subjects that you enjoy until you have built some confidence and are ready to tackle more difficult drawings. If you like one of the subjects more than the others, try practicing it several times. You will improve your skills each time.

I have tried to group the drawings in their order of relative difficulty. For those of you who like structure, just follow the drawings in sequence. If you don't feel like going through the book sequentially, choose the drawings you like and do those first. Starting with easy drawings is critical, since it will insure success. Success breeds self confidence and confidence motivates you to practice. Practice creates an artist.

Instructions For Exercises

PART ONE

Practice makes artists.

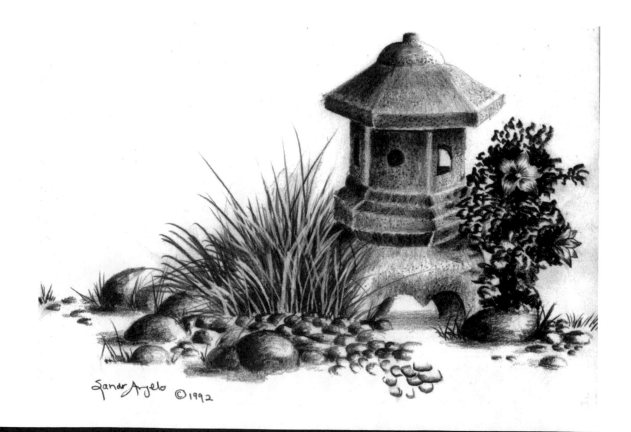

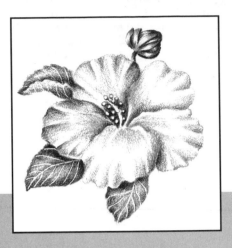

The following pages are filled with a variety of drawings for you to copy. Start with the subjects that you enjoy. If your first attempt isn't satisfactory, try practicing the parts; the tail, the ears, the legs, etc. Then try the drawing again.

Some beginners will end up becoming impressionists, meaning they will draw with loose lines like the ones Gré Hann used to shade her rabbit on page 87. People who like to use sketchy lines hate to draw small. If you fit into that category, you can do these exercises in a separate sketch book. Make the drawings as large as you like. For those of you who are Realists, you wil be just fine drawing the petite, exact renderings in this book

Remember to keep your sketch book private so that you will feel comfortable making mistakes. Review and follow the rest of the exercise instructions on page 41. If you get stuck on a subject, move on to something easier. Keep drawing the things you love because if you love it, you will make time for it and if you put in the time, you will automatically learn to draw.

If you get stumped, try eating a bowl of ice cream or a batch of chocolate chip cookies. Your drawing may not look better, but you'll feel great. Most of all, enjoy your drawing time. In the beginning, drawing is a bit stressful because you're no good at it. However, as your skills improve, you will find it to be one of the most therapeutic and relaxing exercises you can enjoy. So turn this page, and have fun!

As you practice your drawing on the following pages, you may want to use the four step process, as illustrated in this drawing of the dog. Draw the negative space first to be sure your placement is accurate. In the same box, fill in a contour line drawing which will serve as a map for your shapes and shadows. Shade your light and dark values and then place the texture on top of these values. This four step method helps you analyze each object in terms of its shapes, lines, values and textures. Eventually, you won't need to use this process because you will have trained your eye to see these elements.

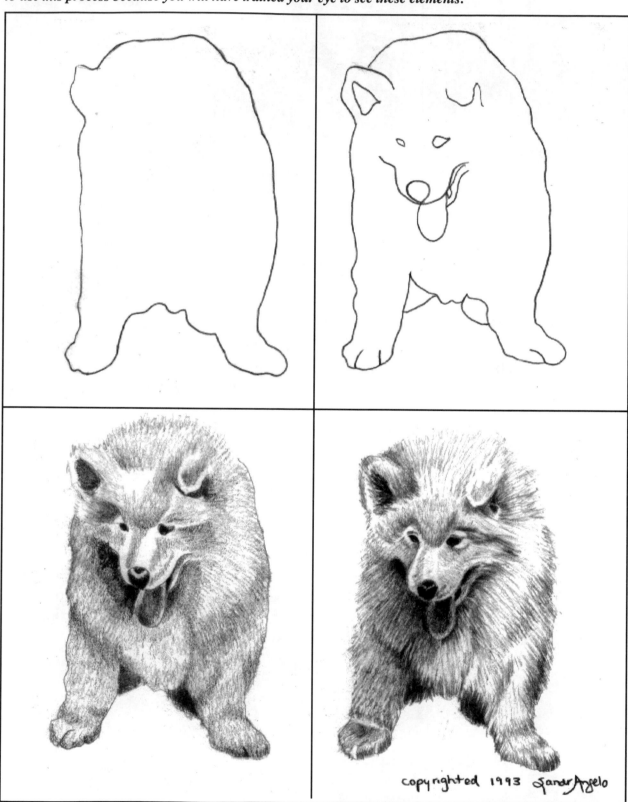

copyrighted 1993 Sandra Angelo

Fig. 57

Sometimes you only need three steps to complete a drawing, as in the flower below. In step one, I completed a negative space drawing. Then I created a map by putting in a contour line drawing, and finally I shaded the object. If your subject doesn't have a distinct texture, you can stop after step three.

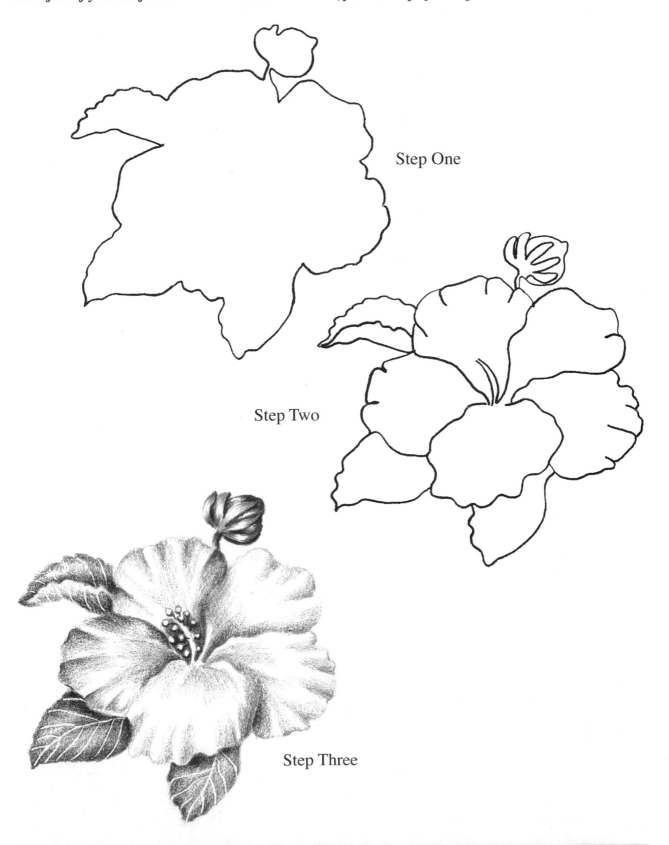

Step One

Step Two

Step Three

Try this drawing on the practice paper. If it seems too hard, consider practicing just a few of the parts of the drawing. If the subject doesn't interest you, you can skip to the next drawing.

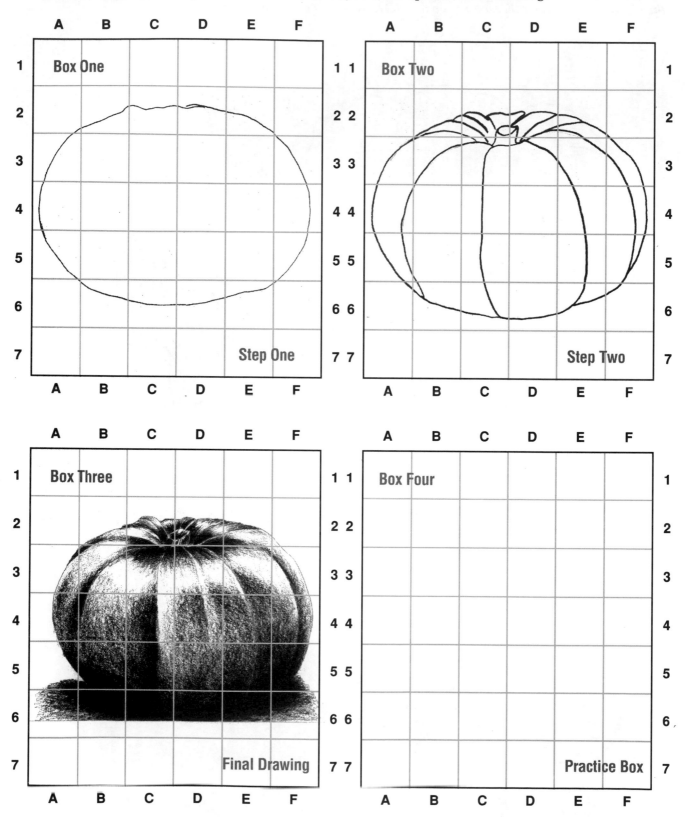

Box One — Step One

Box Two — Step Two

Box Three — Final Drawing

Box Four — Practice Box

Try this drawing on the practice paper. If it seems too hard, consider practicing just a few of the parts of the drawing. If the subject doesn't interest you, you can skip to the next drawing.

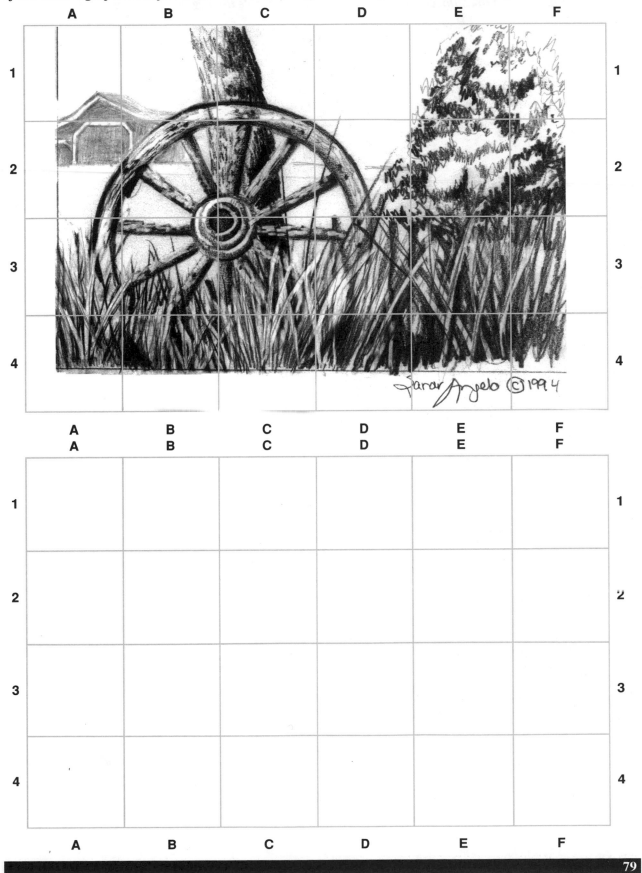

To make your life easier, I have provided a step-by-step drawing of this subject. In Box One, you will see the negative space drawing of the subject. Draw this negative space in Box Four. In Box Two, you will see a contour line drawing of the subject. Complete a line drawing inside the negative space in Box Four.

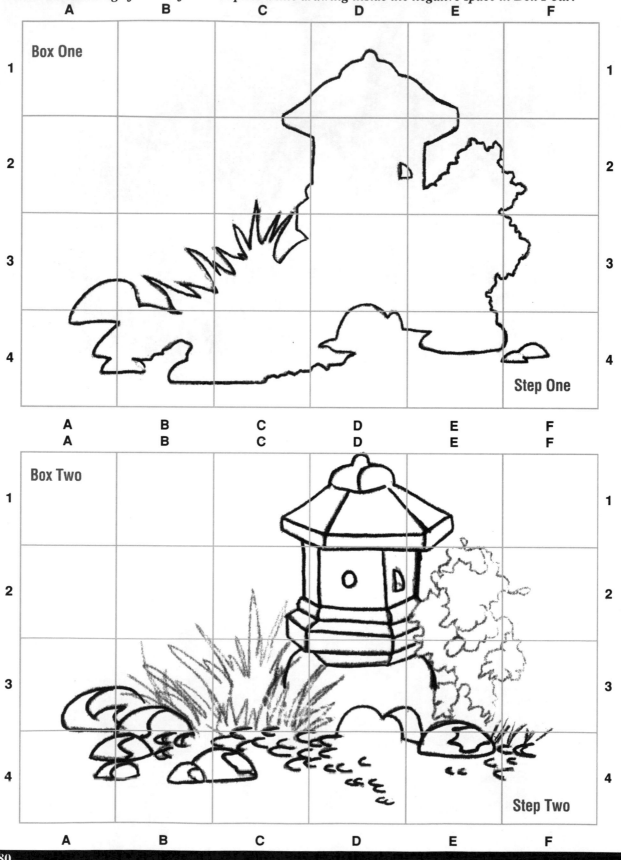

Box One

Step One

Box Two

Step Two

Place the values and textures inside the lines in Box Four.

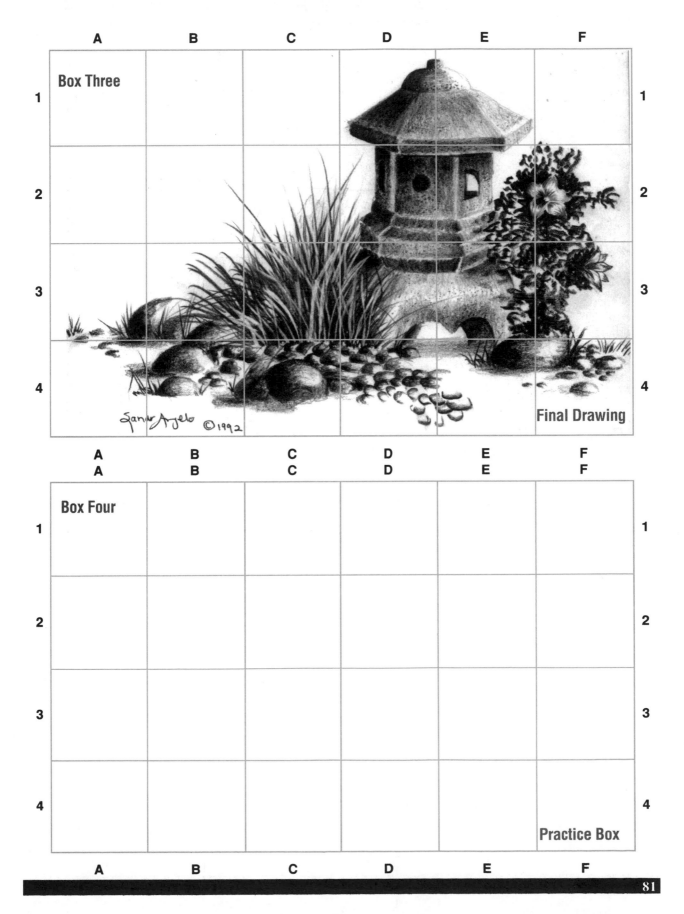

Box Three

Final Drawing

Box Four

Practice Box

To make your life easier, I have provided a step-by-step drawing of this subject. In Box One, you will see the negative space drawing of the subject. Draw this negative space in Box Four. In Box Two, you will see a contour line drawing of the subject. Complete a line drawing inside the negative space in Box Four.

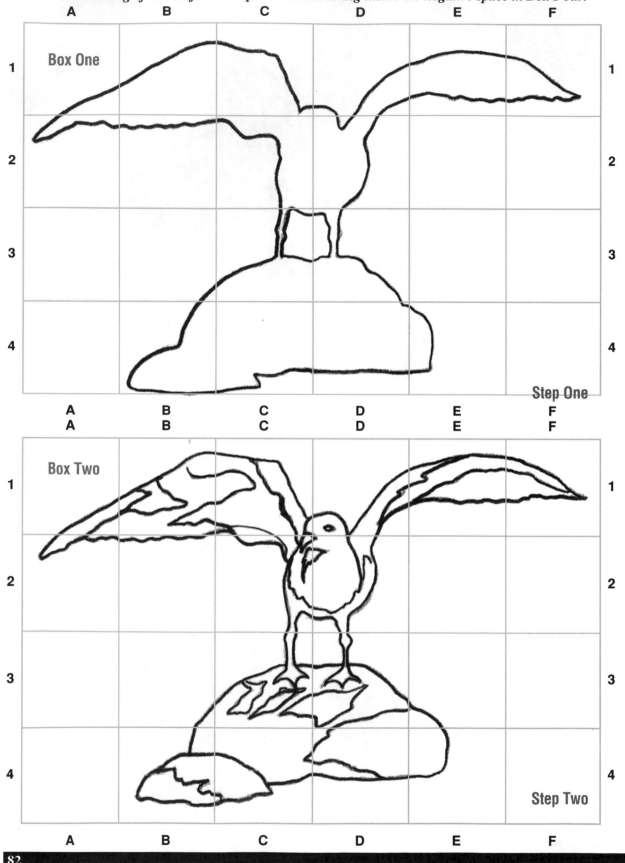

Box One

Step One

Box Two

Step Two

Place the values and textures inside the lines in Box Four.

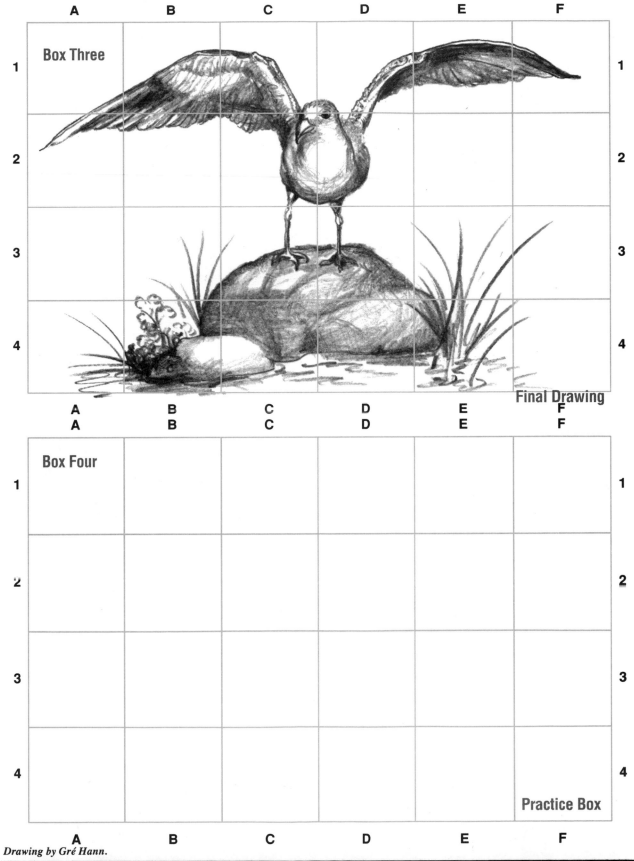

Drawing by Gré Hann.

Copy this drawing on the following page

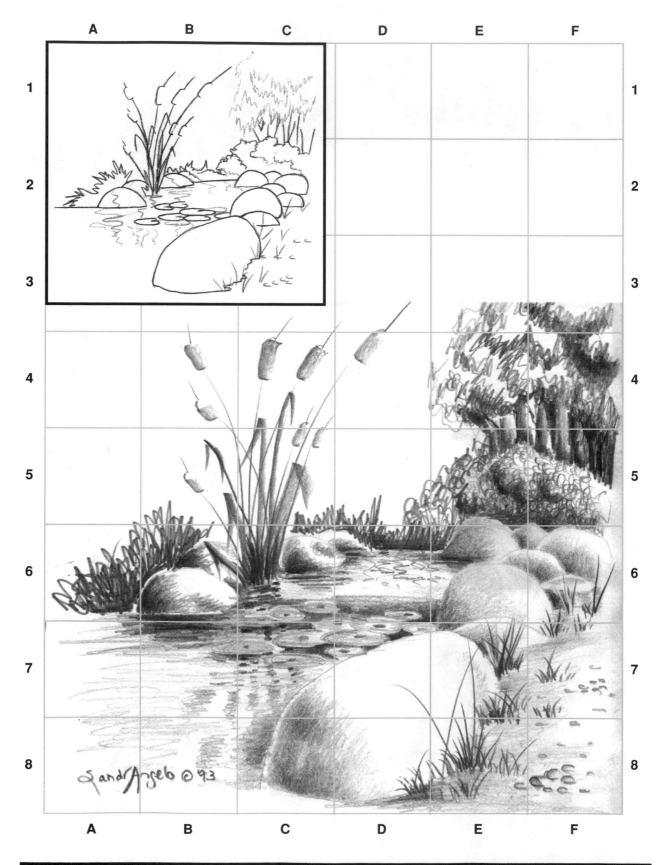

Practice Page

	A	B	C	D	E	F
1						
2						
3						
4						
5						
6						
7						
8						

To make your life easier, I have provided a step-by-step drawing of this subject. In Box One, you will see the negative space drawing of the subject. Draw this negative space in Box Four. In Box Two, you will see a contour line drawing of the subject. Complete a line drawing inside the negative space in Box Four.

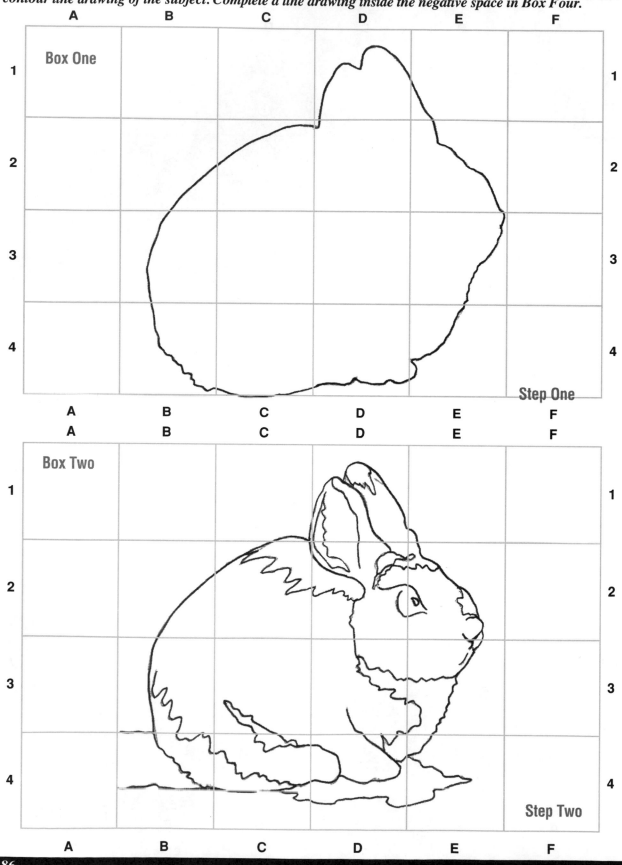

Box One

Step One

Box Two

Step Two

Place the values and textures inside the lines in Box Four.

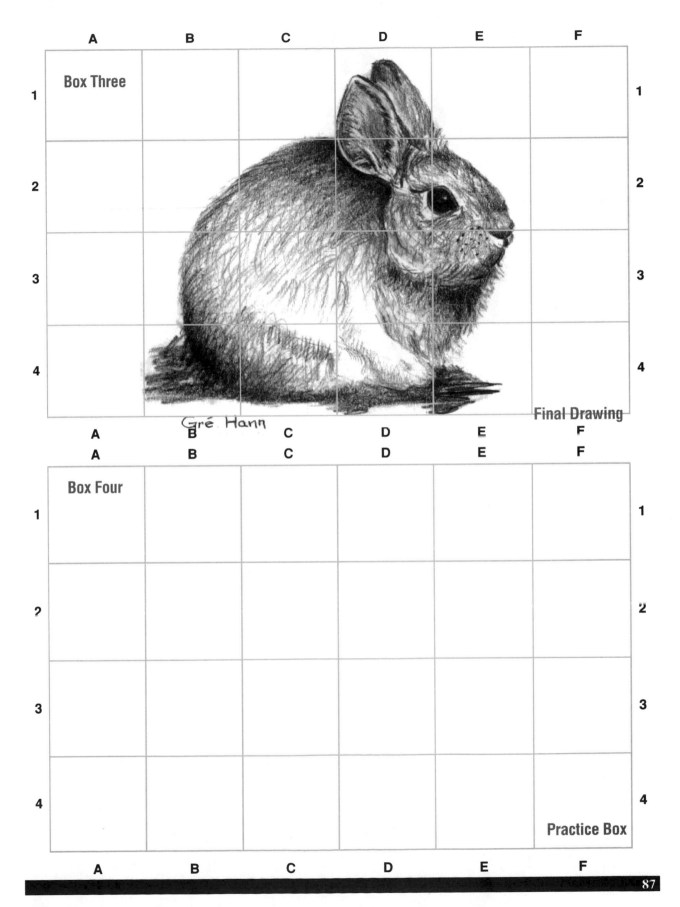

Box Three

Final Drawing

Gré Hann

Box Four

Practice Box

Copy these trees on the following page. If you're having trouble, practice small parts.

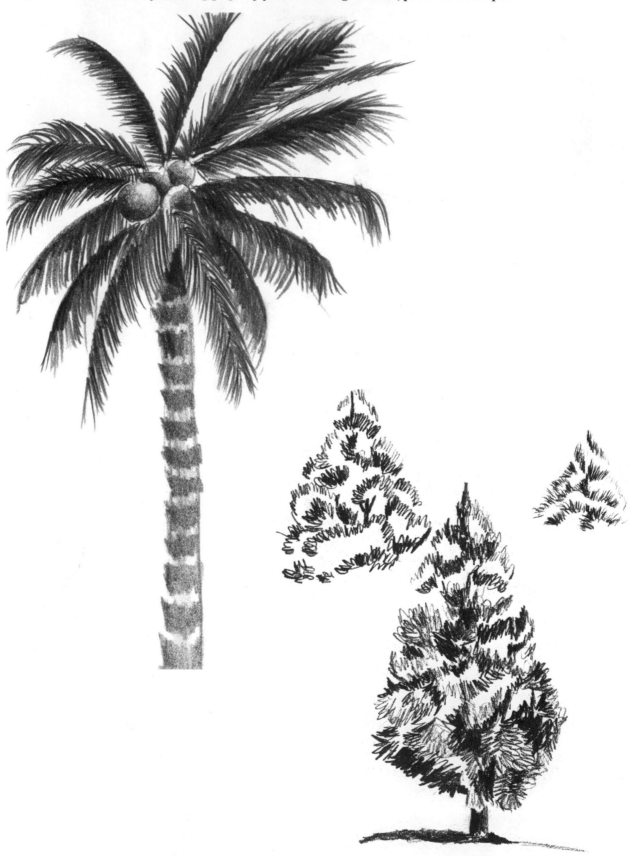

Practice Page

Practice drawing without a grid. Notice that the texture of this tree is different than the tree's texture on the previous page. There are many different types of foliage.

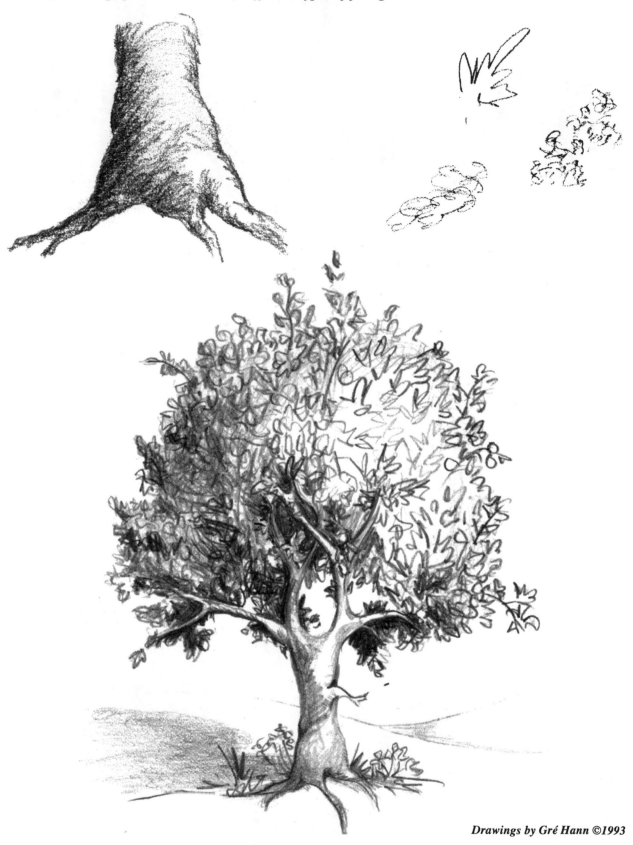

Drawings by Gré Hann ©1993

Practice Page

Copy this drawing on the practice page.

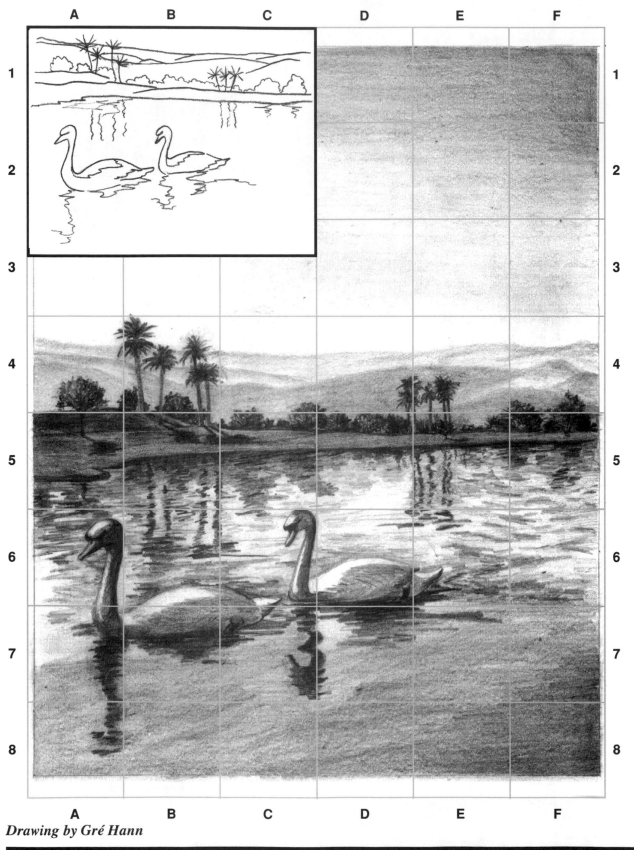

Drawing by Gré Hann

Practice Page

	A	B	C	D	E	F
1						
2						
3						
4						
5						
6						
7						
8						

Copy this drawing on the practice page. If any of the squares are too complicated, subdivide them.

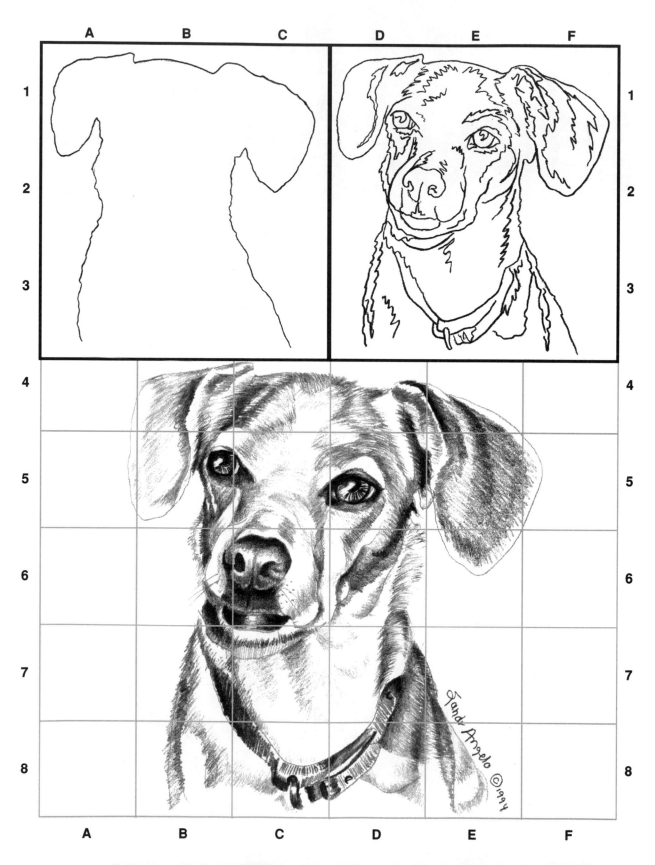

Practice Page

	A	B	C	D	E	F	
1							1
2							2
3							3
4							4
5							5
6							6
7							7
8							8
	A	B	C	D	E	F	

To make your life easier, I have provided a step-by-step drawing of this subject. In Box One, you will see the negative space drawing of the subject. Draw this negative space in Box Four. In Box Two, you will see a contour line drawing of the subject. Complete a line drawing inside the negative space in Box Four.

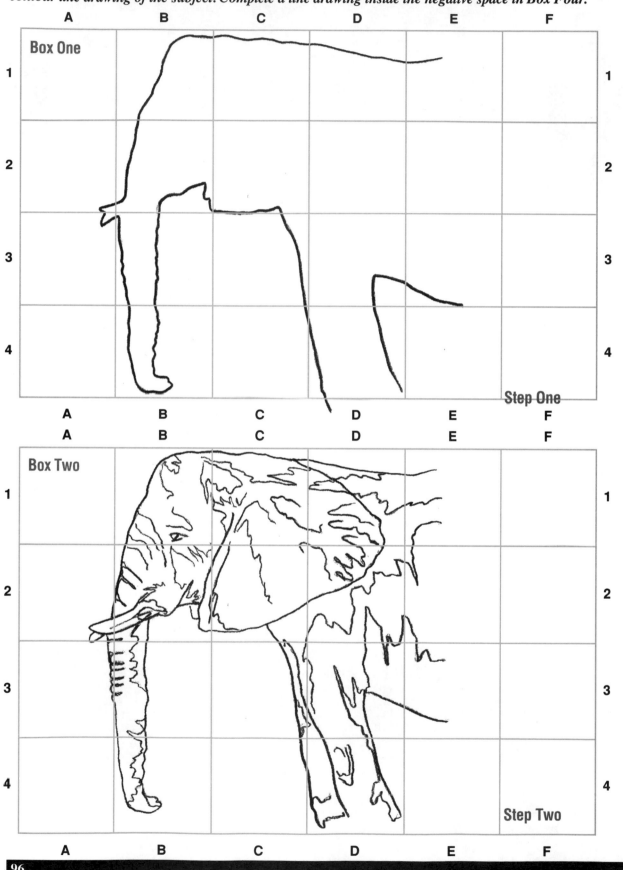

Place the values and textures inside the lines in Box Four.

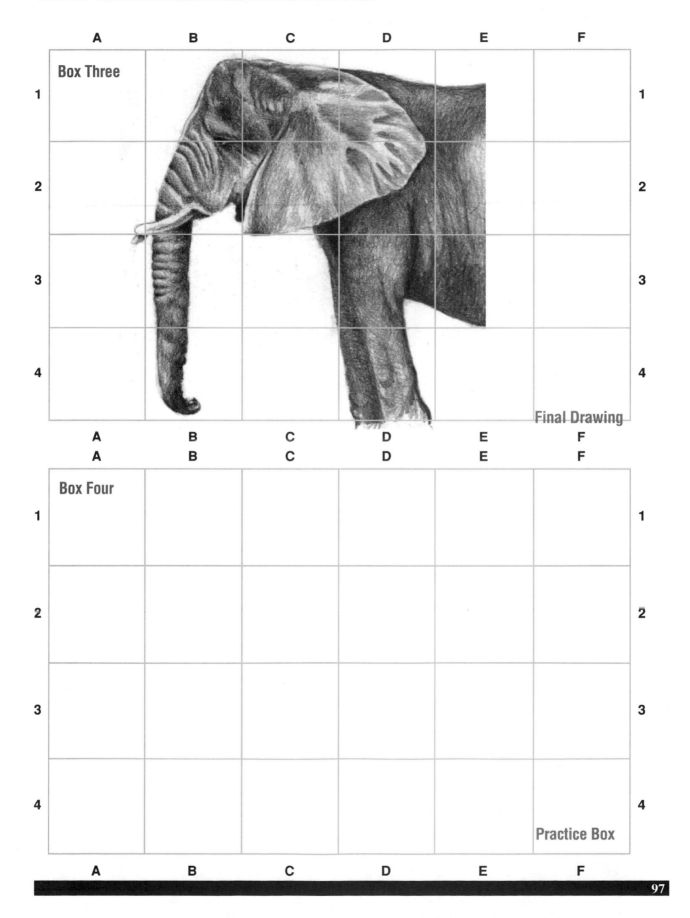

Box Three

Final Drawing

Box Four

Practice Box

Copy this drawing on the practice page.

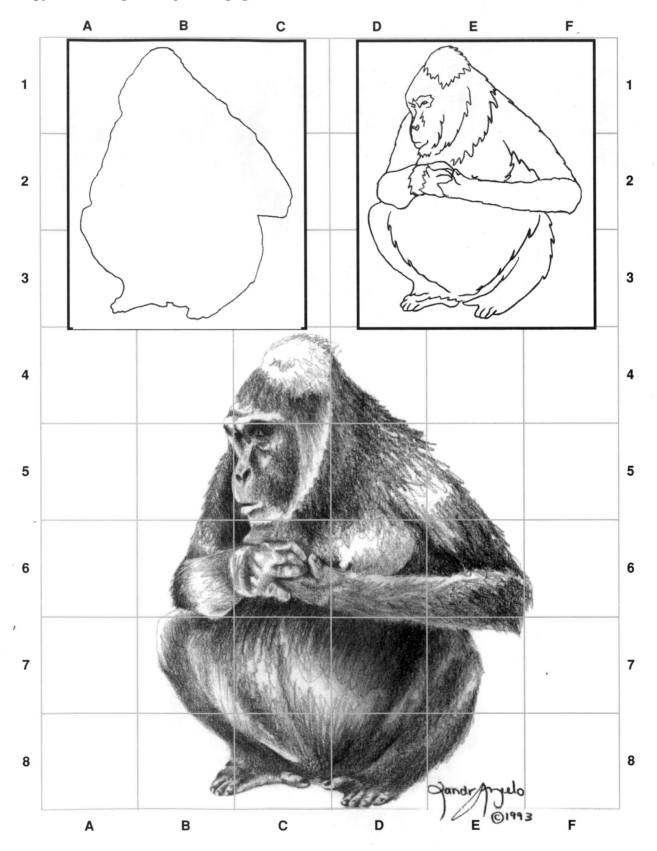

	A	B	C	D	E	F	
1							1
2							2
3							3
4							4
5							5
6							6
7							7
8							8
	A	B	C	D	E	F	

To make your life easier, I have provided a step-by-step drawing of this subject. In Box One, you will see the negative space drawing of the subject. Draw this negative space in Box Four. In Box Two, you will see a contour line drawing of the subject. Complete a line drawing inside the negative space in Box Four.

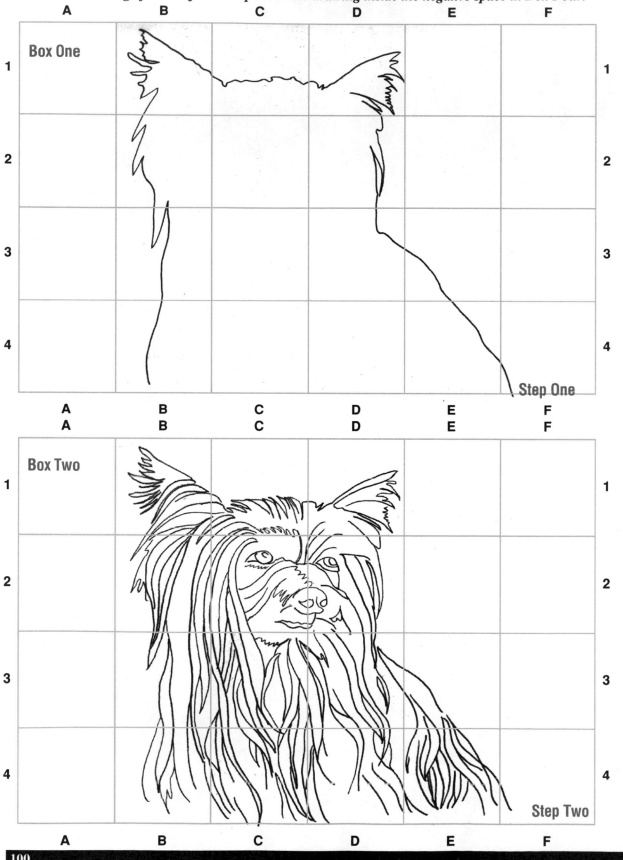

Box One

Step One

Box Two

Step Two

Place the values and textures inside the lines in Box Four.

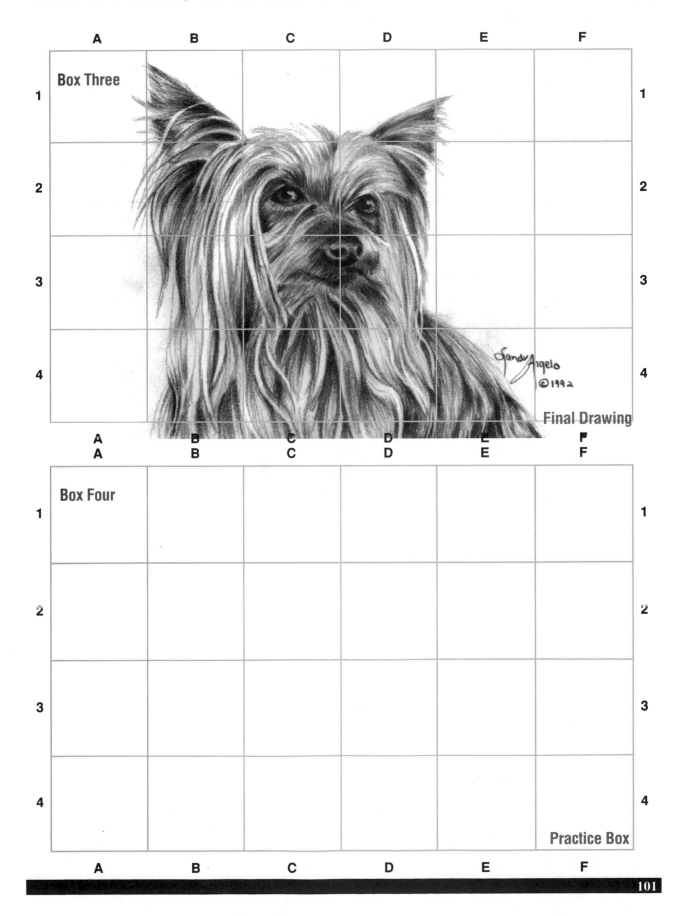

Practice this drawing on the following page.

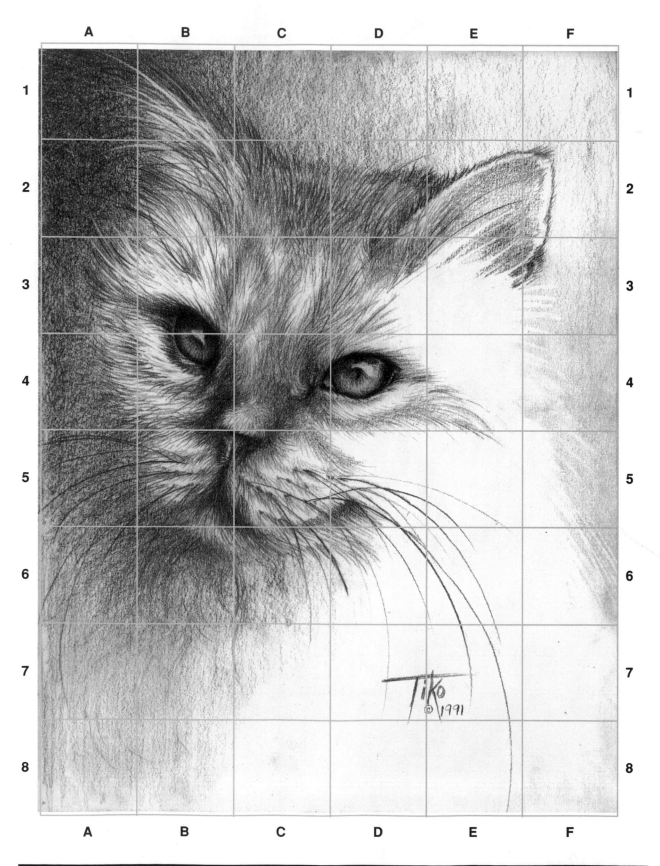

Practice Page

	A	B	C	D	E	F	
1							1
2							2
3							3
4							4
5							5
6							6
7							7
8							8
	A	B	C	D	E	F	

Practice this drawing on the following page.

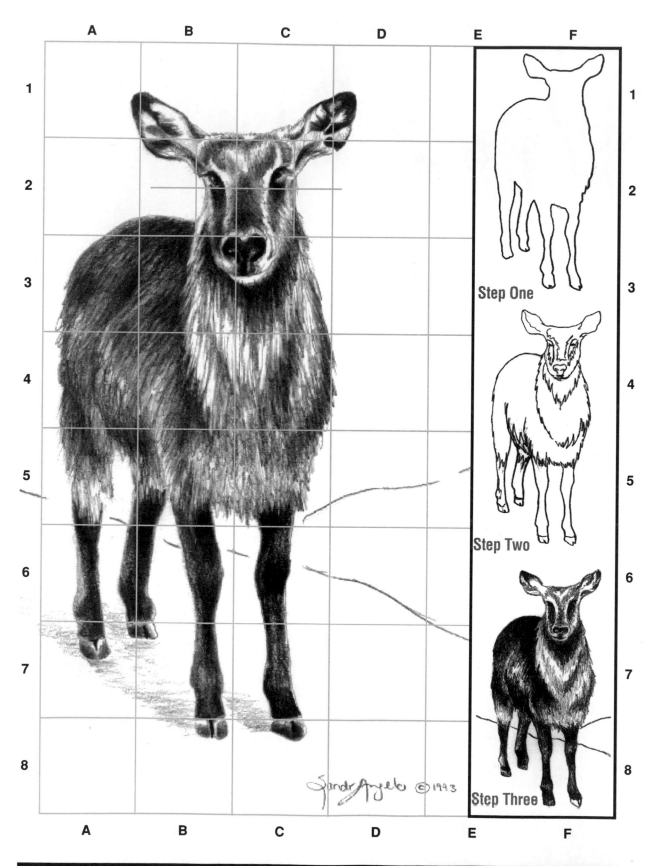

Step One

Step Two

Step Three

Practice Page

	A	B	C	D	E	F
1						
2						
3						
4						
5						
6						
7						
8						

Practice this drawing on the following page.

"Wallowa County" by Tiko Youngdale

Practice Page

	A	B	C	D	E	F	
1							1
2							2
3							3
4							4
5							5
6							6
7							7
8							8
	A	B	C	D	E	F	

Copy this drawing on the practice page.

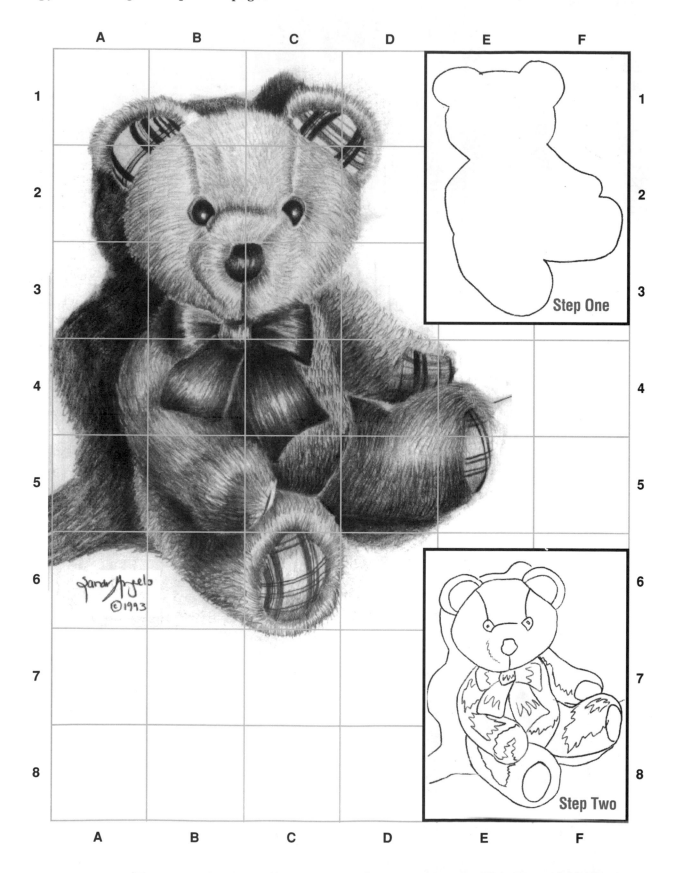

Step One

Step Two

Practice Page

Step Three

Copy this drawing on the practice page.

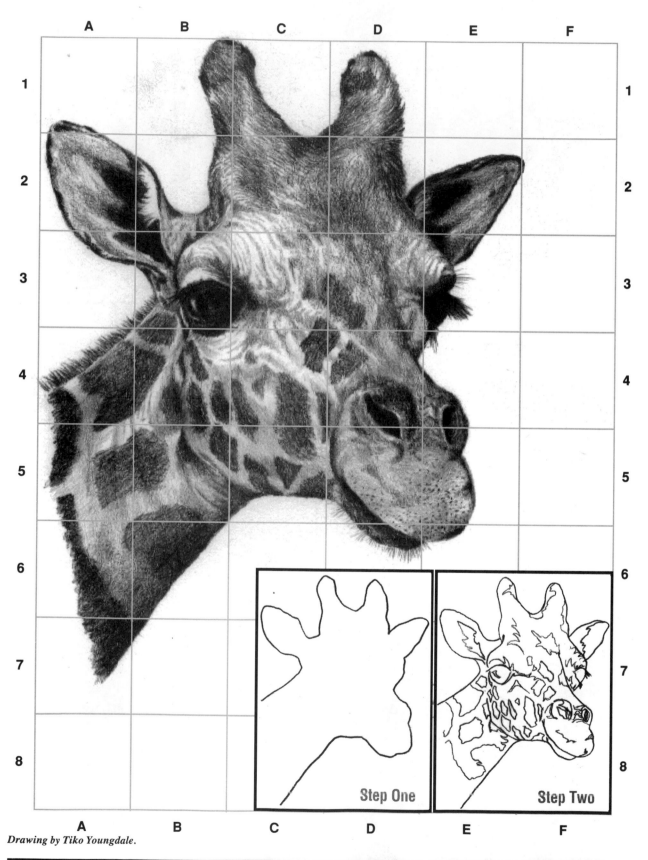

Step One

Step Two

Drawing by Tiko Youngdale.

Practice Page

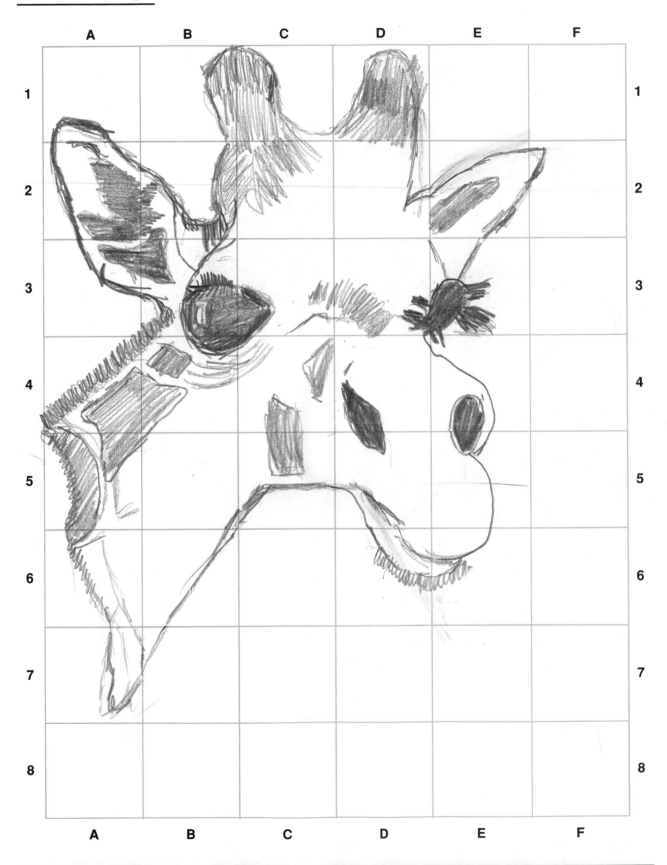

Ey this was my first try 6ood eh?

Copy this drawing on the practice page.

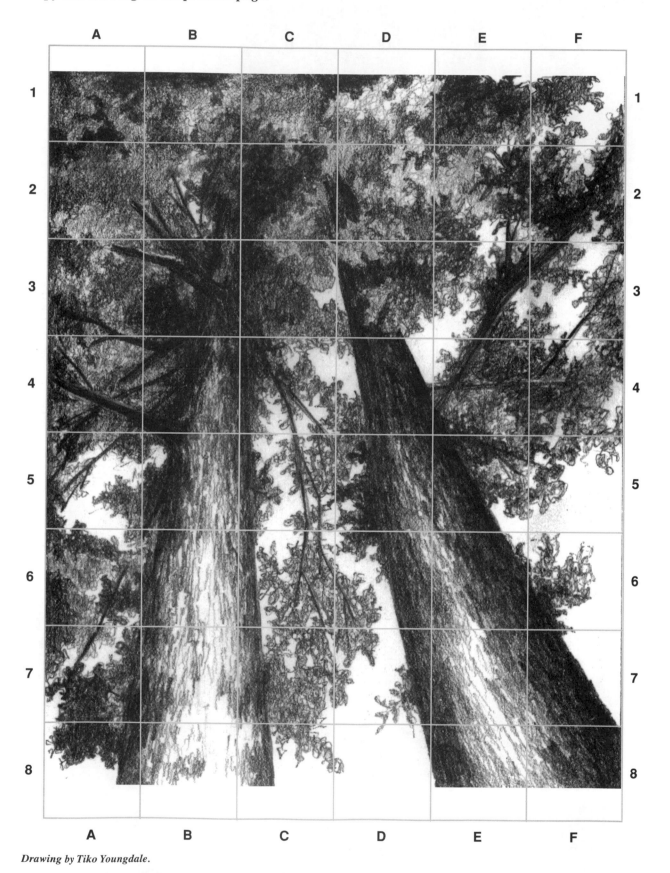

Drawing by Tiko Youngdale.

Practice Page

	A	B	C	D	E	F
1						
2						
3						
4						
5						
6						
7						
8						

Copy this drawing on the practice page.

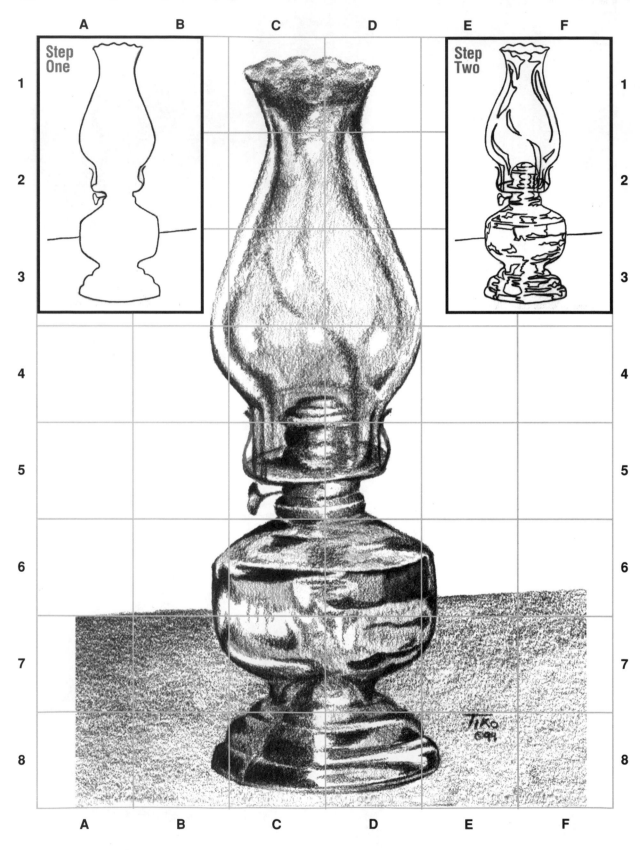

Step One

Step Two

Drawing by Tiko Youngdale.

Practice Page

	A	B	C	D	E	F
1						
2						
3						
4						
5						
6						
7						
8						

PART TWO
Advanced Drawings

Once you have completed the first part of this chapter, consider tackling some of the drawings in this section. Instead of just placing one object on a page, most of these drawings are a full compositon involving an integration of subject and background. Many are extremely detailed and time consuming. If they don't appeal to you, don't do them. They are not critical to your success. For those of you who are Realists, you will love to fuss with the details. Impressionists want to put in one or two twigs, one or two strokes that suggest fur and be done with it. Both philosophies are valid, it's just a matter of personal style. Choose the drawings that appeal to you and you'll be surprised how well you'll do.

Practice this drawing on the following page.

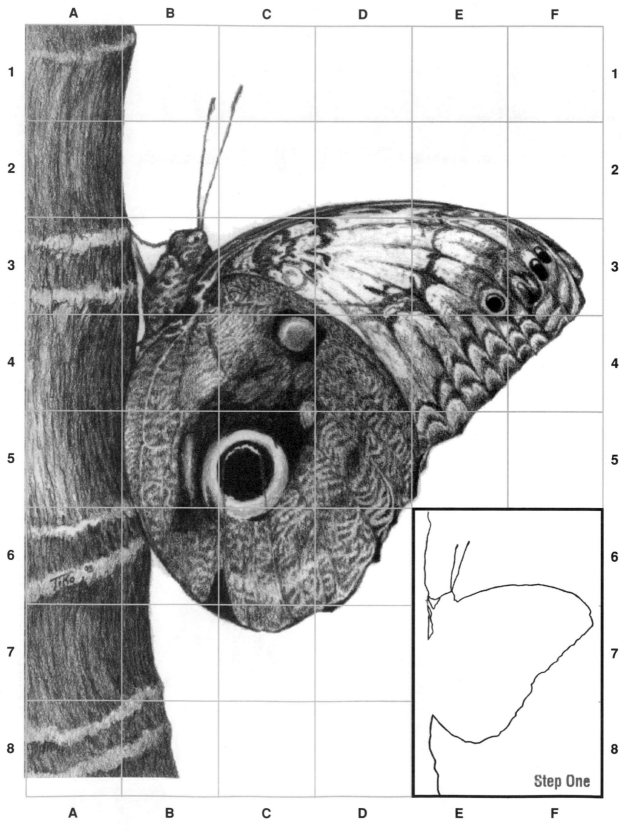

Step One

Drawing by Tiko Youngdale.

Practice Page

Step Two

Practice this drawing on the following page.

Drawing by Tiko Youngdale.

Practice Page

	A	B	C	D	E	F	
1							1
2							2
3							3
4							4
5							5
6							6
7							7
8							8
	A	B	C	D	E	F	

If you love detail, you may enjoy copying this drawing by Tiko Youngdale. If you need to, you can draw a gridded practice sheet. (I suggest a 1/2 inch grid because of the minute detail).

Practice Page

Practice this drawing on the following page.

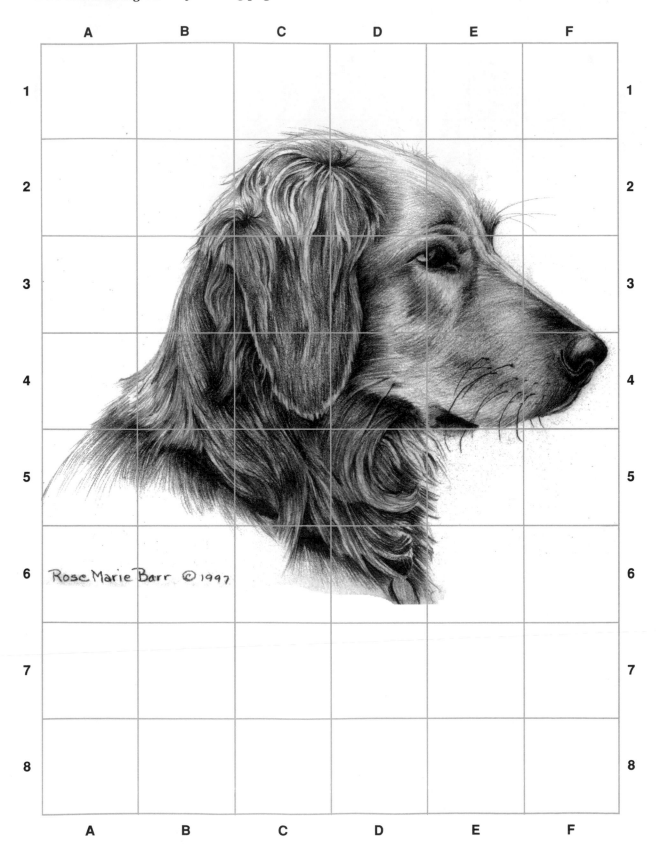

Rose Marie Barr © 1997

Practice Page

	A	B	C	D	E	F
1						
2						
3						
4						
5						
6						
7						
8						

Practice this drawing on the following page.

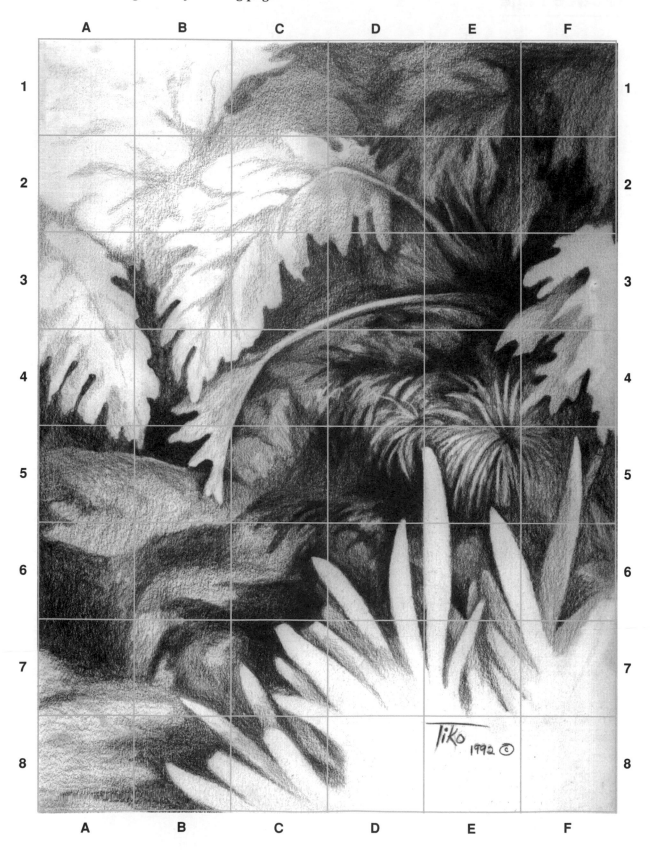

Practice Page

	A	B	C	D	E	F
1						
2						
3						
4						
5						
6						
7						
8						

Practice this drawing on the following page.

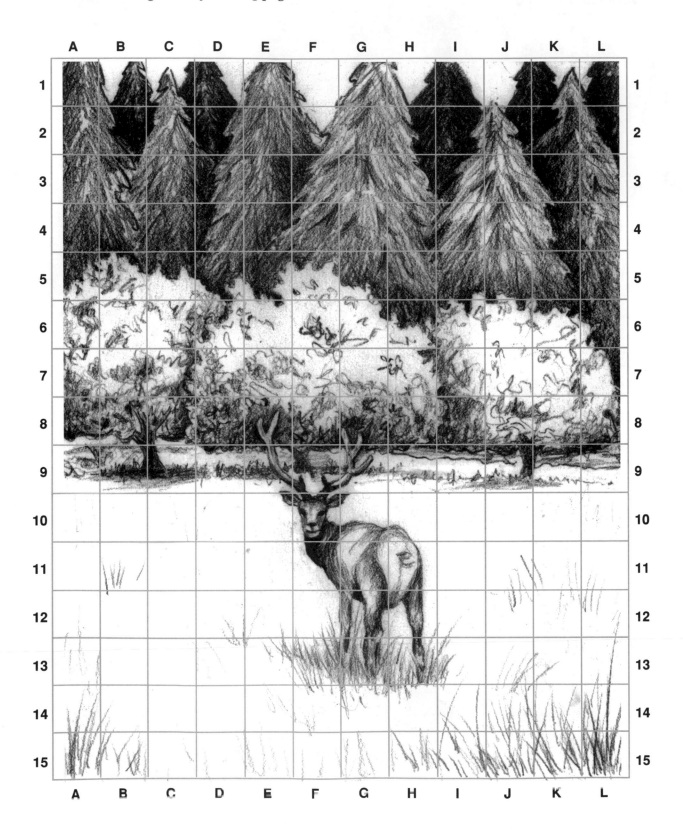

Drawing by Gré Hann.

Practice Page

Practice this drawing on the following page.

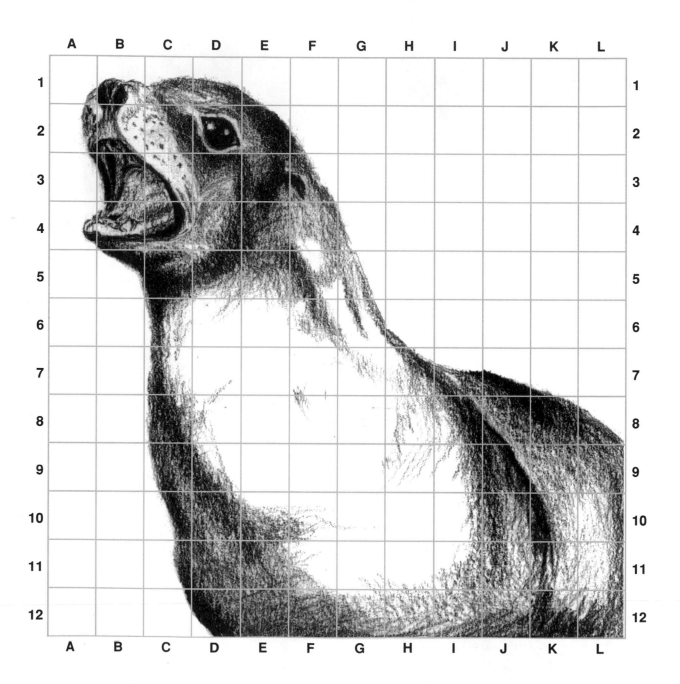

Drawing by Gré Hann.

Practice Page

Practice this drawing on the following page.

Practice Page

	A	B	C	D	E	F
1						
2						
3						
4						
5						
6						
7						
8						

Practice this drawing on the following page.

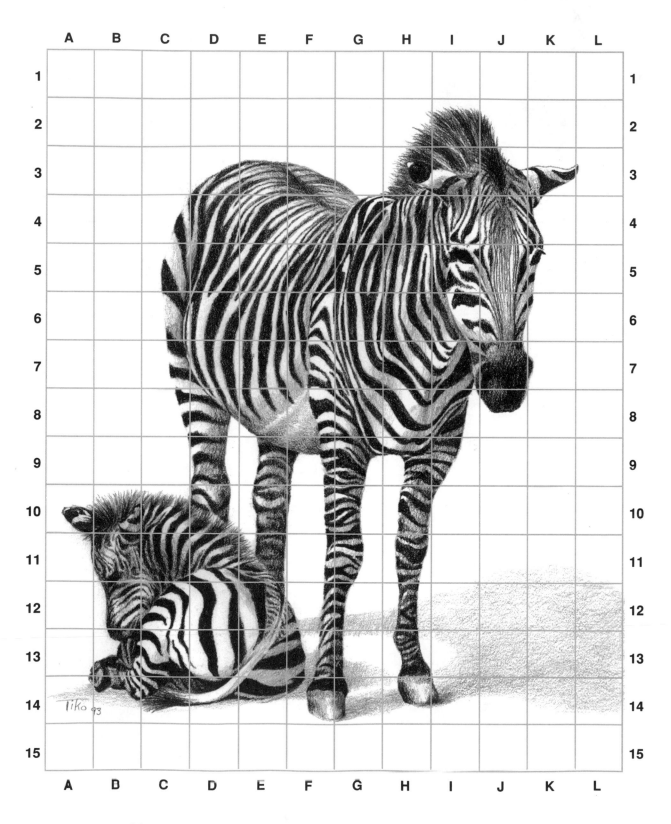

Drawing by Tiko Youngdale.

Practice Page

Practice this drawing on the following page.

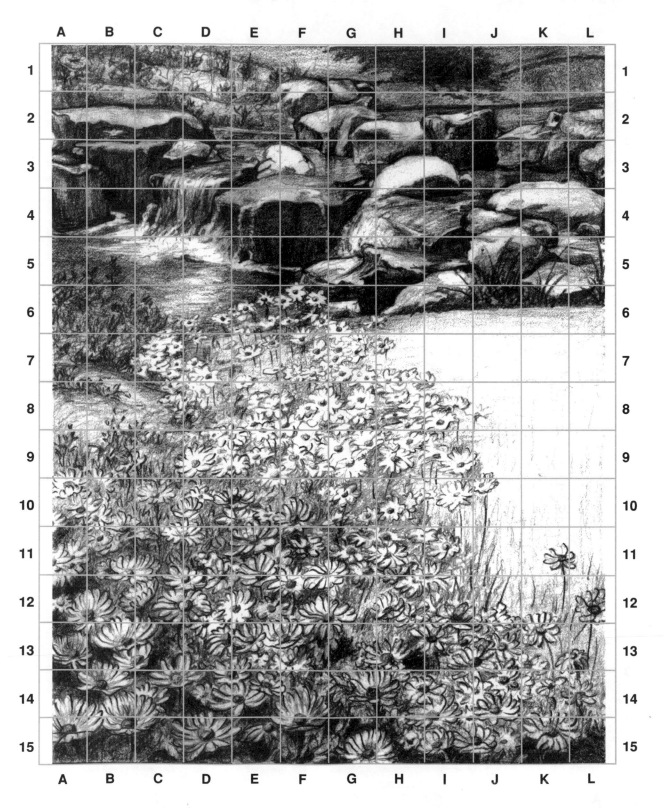

Drawing by Gré Hann.

Practice Page

Practice this drawing on the following page.

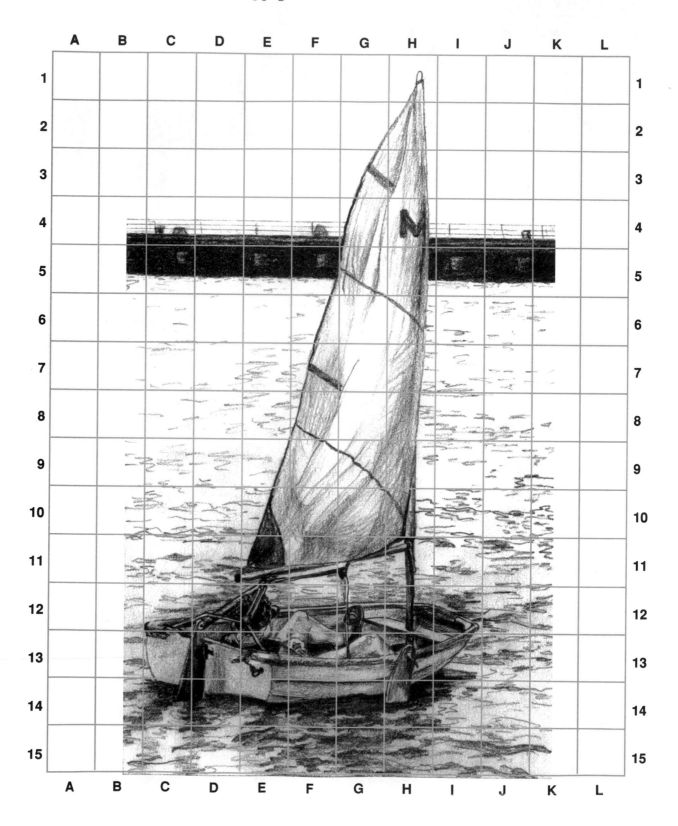

Drawing by Gré Hann.

Practice Page

Practice this drawing on the following page.

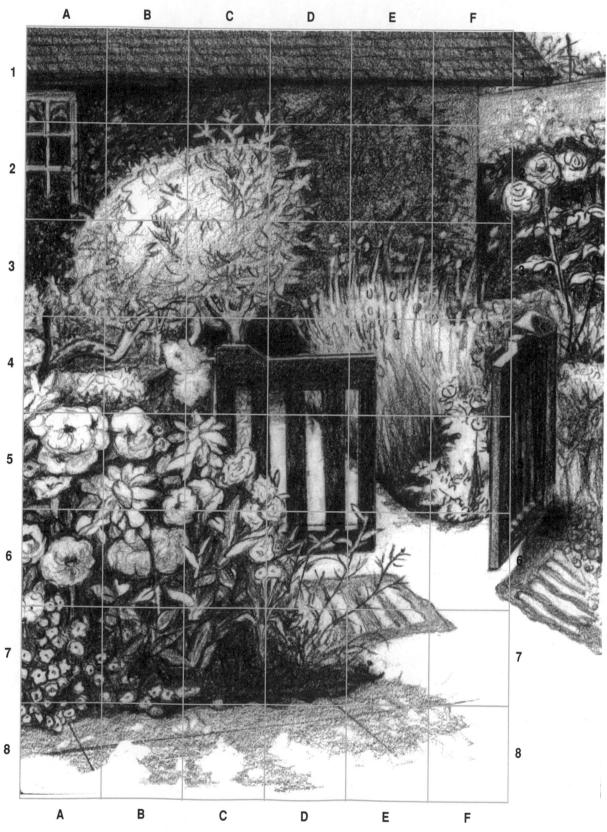

Drawing by Gré Hann.

Practice Page

	A	B	C	D	E	F
1						
2						
3						
4						
5						
6						
7						
8						

SUCCESS STORIES

After taking your beginning and intermediate classes, I now take my own photo references and do original compositions. This drawing of the giraffe was done from a photo I took while I was on safari at the San Diego Wild Animal Park. I 've been so amazed and excited to see how you've been able to transform me into an artist. I think this drawing system is great!"
Peggy Palmer, Housewife

"When I retired, I took up golfing but felt like a fool chasing little white ball around in the grass all day. Besides there weren't enough women out there. So I signed up for your drawing class. I love your classes, Sandi, because you have such a great sense of humor. Old codgers like us feel kinda like a fool when we're all grown up and our drawings look like they were done by a six year old. But your humor really eased us into the drawing process, helped us lighten up, laugh at ourselves and have some fun with it.

Your easy step-by-step methods taught me the basic principles of art. Now I'm enrolled in the local community college taking almost every art course they have. I am exhibiting my work in local banks and libraries and I have a new challenge to conqueror each day. I love drawing! Thanks kid."
Martin Gray, Retired High School Principal

"This is an excellent basic text written in an easy to understand form. Anyone who can read should be able to use it, possibly from grade four to adult. This would be an excellent basic text for public schools. It should solve a lot of problems for both student and teacher."
Jim Nibler, Retired Math Teacher

"Taking your classes was like attending a preschool for the art world. You equipped me with a solid basic foundation in art. I am now finding that the principles you taught me apply to all other forms of art that I'm encountering, including my photography and most recently my computer art. I am having so much fun drawing on my computer but if I had not learned the drawing basics from you, I can see this would be much more difficult. Thanks so much for all you taught me. I am having so much fun!"
Tom Newitt, Anesthesiologist

"I have learned so much from your 'So You Thought You Couldn't Draw' class. I've gone from someone who couldn't not draw at all to someone that is seeing great improvement. This class has increased my ability to really see what is around me and appreciate things that I didn't even notice before. I am enjoying drawing so much! It has added a new dimension to my life.
Betty Nickoloff, Housewife

"When I first met you Sandi, I wasn't sure I could learn to draw. You seemed like a sweet person but when you said, 'Anyone can draw', I was skeptical. In just nine weeks, you took me from drawing like a six year old to drawing work that looked almost like photographs. (You can see Orville's before and after drawings on the cover of this book.) Now I draw all the time and I love it! And I owe it all to you, Sandi."
Orville Thompson, Retired Engineer

"All my life I wanted to draw but was too busy raising a family to pursue it. I was so delighted to discover your drawing classes at the San Diego Wild Animal Park. I knew when you sold me my first set of 12 pencils that my life was going to change but I never dreamed that two years later I would be illustrating ads for the world's number one art company. My work has appeared in their ads in 'The Artist's Magazine' and 'American Artist', for two years straight, and I've had work on TV, videos, magazines and in books. You are the one who taught me the basics. Thanks for helping a dream come true."
Tiko Youngdale, Former Hairdresser

Sandi, You have a magical gift of making difficult concepts seem easy. I love your down to earth, personable style. I have learned so much from you in your drawing classes. You have taken me from weak skills to a high level of proficiency, so much so that my work is now published in books and videos.
Susan Hurst, Real Estate Broker

ACKNOWLEDGEMENTS

First, this book is dedicated to my Creator who granted me purpose by giving me the ability to be a catalyst who develops untapped creative potential. I love the job He gave me!

No great work is ever accomplished without the support of countless people. At the top of my list is my graphic designer who has always shared my vision, believed in my dreams and has given tirelessly of his time and talents to make this book a possibility. Thanks to my fax friend, KC whose irreverent, impertinent missives keep me from taking myself too seriously.

A big thanks goes out to my faithful friend and champion, Chris. Your support, enthusiasm, patience and understanding during tough times and endless encouragement has made a world of difference for me. I sincerely appreciate your help in getting me started with that very first video. What fun we had. Who would have thought the first one would snag an Emmy nomination? Wow! And we were just making it up! You were such a catalyst for my success. You are a truly a gift.

To Tiko, who's been there with me from day one, a very big thank you for stepping on my cape when I tried to become super woman. Thanks for helping me hours on end ever since the days when our office was just a kitchen table. Thanks to both Tiko and Gré for the fabulous illustrations in this book.

I'd like to thank the students who taught me how to teach 'left brained' learners. With their feedback, I discovered how to translate complex classical art concepts into plain English.

To Orville, my favorite, I applaud you. I've watched you grow from a rank amateur into a phenomenal artist who personifies the possibilities that can be achieved by a left brained student who really wants to become an artist. I treasure your friendship and admire your astonishing achievements. You've proved that this stuff really works and even surprised me!

Next, there is a person who has always believed in me, even when my dreams were just wishes spoken into thin air. Thanks Jo. You watched goals turn into reality and part of the reason I succeeded, is your confidence in me. Everyone needs someone who believes.

And finally, this book is a tribute to my parents, Virginia and Ernest McFall, who's amazing life taught me by example that if you have faith, there's nothing you can't do. They taught me to believe, even when there was no glimmer of hope. I've discovered that faith is truly the evidence of things not seen and the antecedent to success. It is my hope that this book will instill faith in you, a belief that you can indeed develop foundational skills which provide you with the ability to express your creative self. And, when you succeed, so will I!

Slip into your fuzzy slippers, curl up in an easy chair and take step-by-step art lessons in your own home.

So You Thought You Couldn't Draw™ Workbook and Companion Video Series:

Drawing Basics You've always wanted to draw but you thought you had to be born with natural talent. It's not true! This video will guide you through your book and transform you from amateur to artist in 4 easy steps. 47 min.

The Easy Way To Draw Flowers, Water & Landscapes Draw along as Sandra Angelo shows easy step-by-step methods for drawing flowers, water, and landscapes... also fast techniques for using water soluble graphite pencils! 45 min.

The Easy Way To Draw Animals Saggy baggy elephant skin, fluffy felines, shaggy dogs, and wiry gorilla fur are among the techniques demonstrated on this exciting video filmed at the San Diego Wild Animal Park. Sandra Angelo's demonstrations are taken from her book so you can draw along. Book sold separately. Nominated for an Emmy! 59 min.

Colored Pencil Video Series

Getting Started With Colored Pencils: I can"t believe that's colored pencil!' Colored pencils can achieve the look of oils, acrylics, watercolors & more without the mess! See the four basic techniques and a discussion of various brands of pencils, papers, and accessories. 46 min.

Special Effects With Colored Pencils: David Dooley demonstrates key secrets for drawing metal and glass. Sandra Angelo shows six watercolor pencil techniques and time saving techniques with colored paper. 55 min.

Time Saving Colored Pencil Techniques: Learn exciting new colored pencil and watercolor pencil techniques which will cut your drawing time in half while dramatically improving results. 75 min.

Realistic Colored Pencils Textures - A Mixed Media Approach: David Dooley and Sandra Angelo demonstrate new special effects for combining colored pencils with a wide variety of media to create textures including fur, skin tones, satin, glass, foliage, dew drops, weathered wood, rusty metal, rocks, grass, shimmering water and more. 70 min.

Drawing Your Loved Ones: People: Key secrets for composing portraits as well as step-by-step techniques for drawing skin tones, hair, mouths, eyes and fabric with colored pencils. Recommend you watch Faces video first. 86 min.

Drawing Your Loved Ones: Pets: Learn secrets for drawing fluffy fur, short hair, droopy skin, eyes, noses, whiskers, and more as Sandra Angelo teaches you how to capture your special friend, your pet. 84 min.

Drawing with Colored Pencils on Wood: Yes, we said wood! People are amazed by the painterly effects that can be achieved by drawing with colored pencils on wood... and there's no mess or toxicity ! Sandra Angelo will share secrets from her new Walnut Hollow book such as: How to prepare the surface, methods for drawing on wood, finishing techniques & more. 58 min.

Building A Nature Sketch book: Create a personalized sketching journal, learn how to record nature's charming babbling brooks, scampering critters, glorious flowers and more. Demonstrations are in colored pencils, graphite, ink and watercolor pencils. Like a scrap book, your journal will be chock full of treasured memories. 75 min.

Also... **The Easy Way To Draw Faces** Learn how to capture a likeness and secrets for putting personality in your portraits as Sandra Angelo demonstrates key secrets for drawing eyes, noses, mouths, skin tones and hair with graphite. 45 min.

Easy Pen & Ink Techniques for Artists and Crafters Learn techniques for combining pen and ink, water soluble pencils and watercolor to create clouds, fur, flowers, foliage, backgrounds plus exciting applications on cloth, wood, & quilts. 75 min.

Paint Like Monet In A Day™- with oil pastels Impressionists and Realists will love the variety of fast, easy ways to create drawings that look like paintings with inexpensive, non toxic, versatile oil pastels. Great for kids too! 40 min.

Color Theory Made Really Easy Tired of ending up with a pile of mud when you try to mix colors? Learn Angelo's simple color mixing solutions & exercises based on traditional color theories. Make your colors come alive. Theories apply to all media. 55 min.

7 Common Drawing Mistakes & How To Correct Them Sandra Angelo saves you hours of agony by teaching simple solutions to the most common drawing problems including: proportion, perspective, creating depth and more. 62 min.

To order videos - Write to: Discover Art, P.O. Box 262424, San Diego, CA 92196 or call Toll Free 1(888) 327-9278

If you're wondering where to start, here are Sandra Angelo's recommendations...

To make it easy, I have grouped our videos in sequential order. Under each collection, I listed supplies that are used on the videos. We generally carry materials that can't be found in art stores. We even go so far as to import some of the finest materials from Europe. Although I get hundreds of requests to recommend art supplies and books, I carefully test each of the products and only sell first quality materials that I highly recommend. You will find that you don't get the same results I describe if you use a lower grade product. This service is provided to you to prevent you the headache of buying the wrong supplies and wasting time and money.

Beginners are more likely to succeed if they build basic skills first like, drawing and color theory. If you don't know how to draw and you can't mix colors, you will always struggle with art. If you are making a lot of mistakes, buy the video, 7 Common Drawing Mistakes and How To Correct Them, which deals with problems such as proportion and perspective. After you've built basic color and drawing skills, buy the videos which introduce you to each new media, like Getting Started In Colored Pencils, Easy Pen and Ink Techniques, etc. These videos teach various techniques and subjects. Then add other colored pencil videos, i.e. learning fast techniques, realistic textures, how to draw on wood and more. If you especially like to draw people or animals, we have two part video collection for each of those subjects. If you are a loose, Impressionistic artist, you will enjoy Paint Like Monet In A Day™ with Oil Pastels.

I highly recommend the daylight lamp which will provide you with color corrected light. Good light is critical for good art. (This light has the added benefit of providing light therapy for those in dreary climates.) Item: 31 & 32.

You can subscribe to additional step-by-step lessons in my magazine columns. Arts and Crafts Magazine has hired me to demystify art supplies, teaching you the differences between various pencils, papers, brushes etc. and then provide you with a step-by-step lesson in the media I review. For subscriptions, call 1(800) 258-0929 and tell them I referred you.

The Decorative Painter hired me to write a series of columns on colored pencil techniques. To receive this magazine, you must be a member which costs $30 but it includes all the magazines and access to their workshops. I will be teaching 2 workshops on colored pencil techniques in June at their convention in Phoenix. For info. re workshops and my column, call 316-269-9300.

To make it easier for you to find the materials, on our order form, I have listed the item # by each product.

If you are a rank beginner, build basic drawing skills by choosing:

1.Book: Item 17: *So You Thought You Couldn't Draw*™ and its **three companion videos, Item: 1, 2, 3 :** *Drawing Basics, The Easy Way To Draw Flowers, Water and Landscapes and The Easy Way to Draw Animals.* Item 23: Wire bound sketch pad with hard cover.

***Materials: Item 21**: 4 Drawing pencils, or Item 22: 12 drawing pencils, Item 25: Grid kit - optional since pages of your book are already gridded. Item 26: Goat hair dust brush, Item 27: Battery sharpener, Item 19: *The Art of Pencil Drawing* book, Item 29: Battery eraser, Item 30: Refills.

Next build color mixing skills with:

2.Video: Item 9: Color Theory Made Really Easy. This provides you with a foundation that will help you mix color in any media.

***Materials: Item 9b:** Color Theory Kit, Item 47: Wire bound watercolor tablet

After studying color theory, you will enjoy our colored pencil video collection:

- **Item 5:** Getting Started with Colored Pencils will show you four basic techniques and explain the differences between various pencils, papers and accessories. After watching this video, you will know which supplies you want to buy. Item 18: Colored Pencil Basics is a companion book for this video. It shows colored pencil techniques step-by-step.

- **Item 11:** Realistic Colored Pencil Textures: Demonstrates key secrets for achieving a variety of textures, such as fur, skin tones, weathered wood, dew drops, water, foliage, etc.

- **Materials: Item 34 or 38:** Starter sets of colored pencils, Item 49: Colored Pencil Tablet - This is a 100% cotton drawing tablet 11x14, Item 26: Goat hair dust brush to control crumbs. If you have a healthy budget and want to round out your pencil collection, pick up Item 37: A set of 36 Verithins hard lead colored pencils to help you place the very finest details without breaking the pencil lead - Item 35 or 36, a set of Art Stix when you want to cover large areas, Item 39: Derwent 120 colored pencils - work well when you want your pencil to stay sharp for light layering. (When I draw animals & faces, that's all I use.) Item 38: Sandra's favorite hard lead colored pencils. Item 40: 100 Fullcolor pencils- medium lead used for techniques such as burnishing. (No wax bloom!)

To learn fast colored pencil techniques, how to work with watercolor pencils, and how to combine colored pencils with other media:

- *Special Effects with Colored Pencils* will show you watercolor pencil techniques and how to draw metal and glass with guest artist David Dooley. Buy video **Item 6:**

- If you have limited time to draw, **Item 10:** Time Saving Colored Pencil Techniques shares neat tricks for speeding the drawing process.

- If you like to draw nature, pick up the video **Item #16** - Building A Nature Sketchbook. If you love detail, combine the pencils with pen and ink, **Item #12:** Easy Pen and Ink Techniques video.

- **Materials: Item 34 or 38:** Starter sets of colored pencils, Item 49: Colored Pencil Tablet -100% cotton drawing tablet 11x14, Item 26 Goat hair dust brush to control crumbs. Item 53: Set of Identipens, Item 29: Battery eraser, Item 30: Refills, Item 44: 24 Watercolor pencils, Item 45: #3 Retractable brush (limited supply), Item 47: Watercolor sketch book, Item 54: Set of 3 black pens (3 nib sizes), Item 55: Set of 6 colored pens - .05 nib.

If you like to work loose and fast:

- Item 7: Video: Paint Like Monet in A Day™ in Oil Pastels

- Materials: Item 56: Cray Pas Oil Pastels set of 25, Item 47: Wire bound, hard cover watercolor tablet size: 7x9

If you like to draw people:

Start with *The Easy Way To Draw Faces* which teaches you how to draw the face in black and white. (It's important to learn these techniques in black and white first.) **Item 4 and Item 23.**

Next, you can watch *Drawing Your Loved Ones: People* - key secrets for drawing eyes, noses, hair, skin tones, how to compose a drawing etc. in colored pencils. **Item 13.**

Materials: Item 34 or 38: Sandra's Favorite colored pencil collection: 24 or 48 Colors **Item 26:** Goat hair dust brush, Item 49 or 51 Colored Pencil Tablet - 100% cotton drawing tablet 11x14 or 100% cotton Vellum Bristol, 11x14, **Item 50:** Hard bound colored paper tablet - $17.97. **Item 29:** Battery eraser **Item 30:** Refills, **Item 28:** Vertical electric sharpener for wide Derwent pencils.

If you like to draw animals:

Start with video: **Item 3:** *The Easy Way To Draw Animals* which teaches you how to draw a variety of animals in black and white. **Item 17** is a companion workbook that has the same drawings demonstrated on the video. **Item 23 or 24** will be good for practicing you graphite drawing or pen & ink.

Next, you can watch *Drawing Your Loved Ones: Pets* - teaches key secrets for drawing eyes, noses, fur, whiskers, how to compose a drawing etc. in colored pencils. **Item 14.**

Materials: Item 38: Sandra's Favorite colored pencil collection: 48 Colors (very limited supply left) **Item 34 or 38** Starter sets of colored pencils, Item 26 Goat hair dust brush, **Item 49 or 51** Colored Pencil Tablet - 100% cotton drawing or Bristol tablet 11x14, **Item 50:** Hard bound colored paper tablet - $17.97. **Item 29:** Battery eraser Item 30: Refills, Item 28: Vertical electric sharpener

If you want to get the look of paint on wood, but don't want the mess:

We just released a new title, **Item 15:** *Drawing with Colored Pencils on Wood.* This video has a companion book titled **Item 20:** Create With Colored Pencils on Wood which contains the designs and instructions demonstrated on the video.

Materials: Item 34: Starter set of soft colored pencils, or **Item 40:** 100 med./ soft pencils **Item 26:** Goat hair dust brush, **Item 53:** Identipens, **Item 29:** Battery eraser, **Item 30:** Refills, **Item 27:** Portable battery sharpener.

How To Choose The Right Paper:

If you are using colored pencils, you need a paper which has a good tooth or 'bite'. The vellum or regular finish found in **Item #51 and #52** will provide you with a great textured surface that will accept multiple layers of colored pencil. This texture is ideal for burnishing, transparent layering and the colorless blender. If you plan to build a value under drawing (as described on video **Item #5**, you can use the smoother, plate finish in tablet **Item: 52.** Use plate finish for: 1) Drawing with pen and ink because a pen will not bleed on a smooth surface, 2) Drawing with graphite because you can get very soft blending such for smooth subjects such as skin, soft fur, etc. Sandra uses this plate finish for all her performance drawings in graphite. For fooling around with graphite and pen and ink, she uses the tablet listed in **Item: 23 or 24.**

If you are working with watercolor pencils, you must use a watercolor paper because it has been treated with sizing and will not disintegrate. **Item #47** is ideal for practice and when you wish to perform, use **Item #48.** For oil pastels, select the watercolor tablet in **Item # 47.**

See order form for details on shipping and handling, taxes, etc.

ORDER FORM: This form is dated 2/98. Vendors raise prices once or twice a year and occasionally items are discontinued, so be sure to call to make sure items are still available and pricing is current. All prices and availability subject to change without notice.

VIDEOS: (Videos range 40 to 90 Min) See next page for volume **discounts** on videos. Order rec'd:_____Order mld: _____

So You Thought You Couldn't Draw™ 3 Video Series: Companion for book #17 below.

1. Drawing Basics, How To Shade & More	$50.00	**1.** _____
2. The Easy Way To Draw - Landscapes, Water & Flowers	$50.00	**2.** _____
3. The Easy Way To Draw - Cats, Dogs & Wild Animals	$50.00	**3.** _____
4. The Easy Way To Draw - Faces	$50.00	4._____
5. Getting Started With Colored Pencils	$50.00	5._____
6. Special Effects With Colored Pencils	$50.00	6._____
7. Paint Like Monet In A Day™ with oil pastels	$50.00	7._____
8. 7 Common Drawing Mistakes - **Great for Beginners** & How To Correct Them	$50.00	8._____
9. Color Theory Made Really Easy	$50.00	9._____
Supply Kit for Color Theory Video Value: $45.00	**$35**	9b._____
7 acrylic paints / primaries & secondaries - used on the color theory video		
10. Time Saving Colored Pencil Techniques	$50.00	10._____
11. Realistic Colored Pencil Textures, A Mixed Media Approach	$50.00	11._____
12. Easy Pen & Ink Techniques for Artist's & Crafters	$50.00	12._____
13. Drawing Your Loved Ones: People	$50.00	13._____
14. Drawing Your Loved Ones: Pets	$50.00	14._____
15. Drawing with Colored Pencils on Wood	$50.00	15._____
16. Building A Nature Sketch Book™	$50.00	16._____

BOOKS: (1st. book is companion for Videos 1,2,3

So You Thought You Couldn't Draw™ - by Sandra Angelo	$24.97	17._____
Colored Pencil Basics by Sandra Angelo (Videos 5,6)	$ 7.97	18._____
The Art of Pencil Drawing- Franks	$19.97	19._____
Create with Colored Pencils on Wood by Sandra Angelo (goes with Video 15)	$ 7.97	20._____

SANDRA'S FAVORITE DRAWING SUPPLIES:

Sandra's favorite sketching graphite pencils, 4 in a set	$ 5.00	21._____
Sandra's favorite sketching graphite pencils, 12 in a set	$13.95	22._____
Sandra's Favorite wire bound practice 7x9 sketch tablet - **hard cover**	$ 17.97	23._____
Beginner's 9x12 practice sketch pad	$ 9.97	24._____
Grid kit	$ 8.97	25._____
Bamboo Goat Hair Dust Brush (like on video)	$ 7.97	26._____
Portable Battery Operated Sharpener used by Sandra	$17.97	27._____
Vertical Mounted Electric Sharpener used by Sandra	$49.97	28._____
Battery Operated Eraser (like on video)	$49.97	29._____
Eraser Refills - 70 in a pack	$ 8.97	30._____
Daylight Portable Lamp - provides daylight at night	$77.97	31 _____
Replacement bulb	$14.97	32._____
Packet of transfer paper, white, graphite, non photo blue, yellow	$10.97	33._____

SANDRA'S FAVORITE COLORED PENCIL SUPPLIES:

Starter Set of colored pencils set of hard colored pencils: 24	$27.97	34._____
Prismacolor Art Stix - set of 24	$27.97	35._____
Berol Prismacolor Art Stix- set of 48	$57.97	36._____
Set of 36 Verithin colored pencils - very hard lead for detail only	$24.97	37._____
Sandra's Favorite med. hard lead pencils: 48 colors for drawing portraits and animals: SALE:	REG: $57.00 $49.97	38._____
Derwent 120 Colored Pencils in Wooden case Reg. $200. Med/Hard lead SALE Price:	$179	39._____
Fullcolor 100 colored pencil set in wooden box (no wax bloom!)	$179	40._____
Colored Pencil Carousel	$19.97	41._____
Pro Laser White - highlighter for colored pencil drawings	$ 8.97	42._____
Box of six colorless blenders	$19.97	43._____

SANDRA'S FAVORITE WATERCOLOR PENCIL SUPPLIES:

Watercolor pencils - 24 colors	$27.97	44._____
#3 Retractable Watercolor brush Discontinued: Very limited supply	$17.97	45._____
Water soluble graphite set of 12	$16.97	46._____
Practice paper: Wire bound, hard cover, 7x9 watercolor tablet	$17.77	47._____
Performance paper Watercolor Block 9x12 - archival	$36.77	48._____

Sandra's Favorite Colored Pencil Papers

100% Cotton Colored Pencil practice tablet: White 11x14	$17.97	49. _____
Wire bound hard cover colored paper tablet: Colored paper 7x9	$17.97	50. _____
100% cotton 2 ply Bristol board Regular finish White 11x14	$17.97	51. _____
100% cotton 2 ply Bristol board Plate finish (smooth) White 11x14	$17.97	52. _____

(The plate finish is also good for graphite and pen and ink.)

Sandra's Favorite Pen and Ink Supplies. See item 52 and 23 for pen and ink paper.

Set of 8 Identipens	$16.97	53. _____
Set of 3 black pens: 3 nib sizes:	$ 9.00	54. _____
Set of 6 colored pens	$18.00	55. _____

Supplies for video: Paint Like Monet in a Day™ set of oil pastels $16.97 56._____

Volume DISCOUNT on videos: 2 @ $77, 4 @ $37 ea., 8 @ $27 ea. Entire Collection 50% off @ $395.

Must mention sytd book to get this discount on videos: Sub Total: _____

CA Residents add 7.75 % sales tax: _____

SHIPPING & HANDLING USA:

(Shipping prices are based on	$ 0 - 50	$ 5.98
orders going to same address.)	$ 51 - 100	$ 9.98
Order more than $700 -Free US shipping	$101 - 300	$14.98
	$301 - 700	$17.98

USA S&H: _____

Canada $5 surcharge

Outside USA, to expedite order, supply your MC or VISA # for S&H charges. TOTAL: _____

Please tell us how you heard about us: _____

If you PAY WITH MASTER CARD OR VISA you can place an order TOLL FREE
1-888-327-9278 - this toll free number is for orders outside San Diego County only - In San Diego
County or For Info: call (619) 578-6005. FAX YOUR ORDER TO: (619) 578-0837.

Method of payment: _____Check: Payable to Discover Art OR _____ Master Card _____Visa

Account Number # _____ Expiration Date: _____

Signature _____ Print Name _____

Please Print:

Your Name _____ Phone_____

Address_____

City _____ State_____ Zip _____

Mail payment and order form to: Discover Art, P.O. Box 262424, San Diego, CA 92196
DELIVERY: ALLOW 4-6 WEEKS. (If all items are in stock, order is shipped right away...We allow 4-6 weeks
because some of our products are shipped from Europe.) Prices & availability subject to change.

REFUND / RETURN POLICY: Consider carefully before buying. There are NO REFUNDS issued. Our
margins are so low that we regret that we cannot accept any returns or exchanges. Our supplier does not accept
returns so we can't afford to absorb the losses. (For a no charge replacement of a defective video, call Daryl
Tyler at 1(714)630-5455.)

_____I am interested in hiring Sandra Angelo for a workshop. Please send topics and a fee schedule.